HIDE IN PLAIN SIGHT

HIDE IN PLAIN SIGHT

100 INSPIRING WAYS TO IMPROVE YOUR TRAVEL PHOTOGRAPHY

by Jens Lennartsson

new Heroes & Pioneers

INTRODUCTION

If it were possible, I'd love to take pictures without a camera. Except for that wonderful click when you press the button, I'm totally uninterested in everything related to equipment. Every time someone says to me, "Oh, that's a great picture! What camera did you use?" I want to punch him in the face. With a car! Because personally, I think that dude has missed the entire point of photography. If you put all your energy into finding the perfect camera, you'll miss 99 percent of what you need to take good pictures.

As a personal challenge, I started the 100 Days project early in 2012. I wanted to share what I had learned through my travels and see what would happen if I talked about photography with almost no mention of the gear I was using. Instead, the project would focus on the human elements of photography. The meetings, feelings and moods. This project has now become the book you are holding in your hands.

You already have everything you need to become a great travel photographer. With these pages, I'm hoping you will get inspired to trust the knowledge, creativity and intuition you already possess. In the end, there is no right or wrong way to do things. Just because things are usually done in a certain way, doesn't mean that it has to be your way. You simply need to learn what works for you.

Travel photography is about what you experience, not what you carry around your neck.

1

GET DIRTY!

If you're dressed in your most expensive jeans, stiletto heels and a suede jacket that will dissolve in damp weather, you'll spend most of your time worrying about staying clean. Being a photographer gives you permission to get sandy, soaked, slimy and sweaty. The grime will wash off, but the pictures will last forever. Wear durable clothes while shooting - not to mention comfortable shoes.

Rooftop Films is an organization that runs pop-up movie theaters on 20 different rooftops around New York City for about six months a year. I wanted to catch the faces of the people watching a documentary about the world's strongest man, but the low light made it impossible to do it hand-held and I didn't have a tripod. Lying down in a huge puddle of water, with my hip and both elbows on the ground, I waited for a bright part of the movie. It took me almost a hundred shots to get the lighting and expressions right.

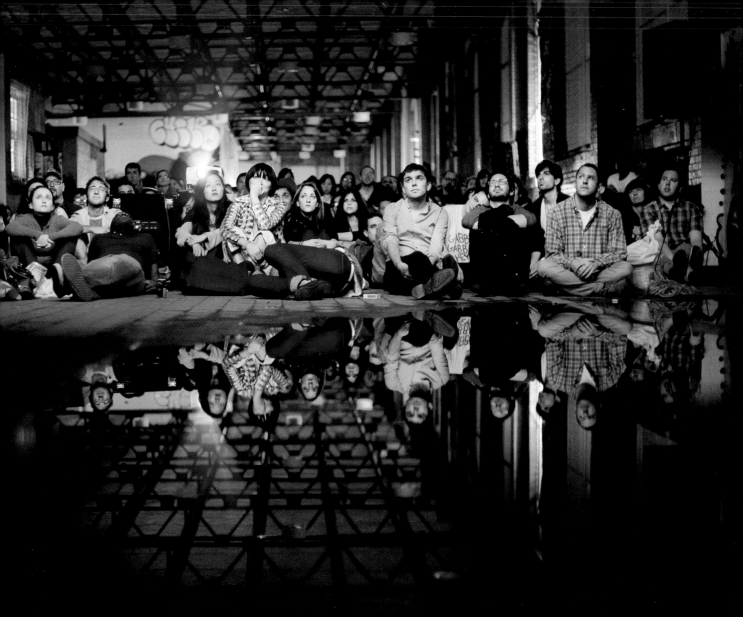

2

MORNING HAS BROKEN

During my teenage years, I developed a very sophisticated routine that allowed me to get out of bed, get dressed, give the breakfast that my mother prepared for me to the dog, brush my teeth and run to the bus in less than 7 minutes. Your bed can feel amazingly comfortable and you want nothing more than to stay in it. But if you do, you are missing out on some of the best light of the day! Witnessing a city waking up will certainly make up for those hours of lost sleep. Get up before the sun to give yourself hours of great image-making opportunities.

I silently untied one of the yellow, plastic kayaks from the wobbly bamboo paths that connected about 20 bungalows to make a small floating village. It was one of many similar villages located in the bays of Khao Sok National Park in southern Thailand. Without a sound, I sliced through the dark green water as if sliding on a gigantic glass tile. I was the only human being awake. I sat in solitude for a long time, waiting for the sun to rise. A couple of cicadas started to sing.

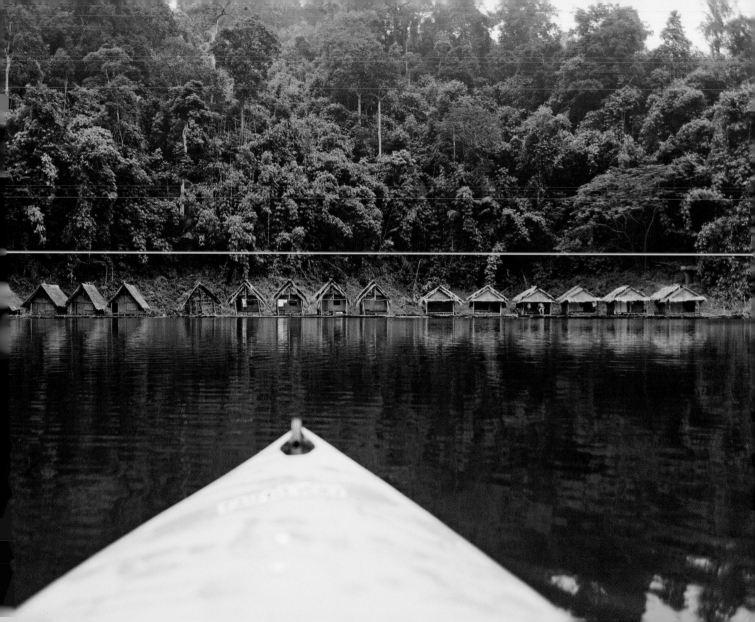

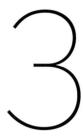

3

PRACTICE YOUR SCALES

As you stand looking up at that gigantic redwood tree, it will feel like the most majestic thing in the world. But why does it look like a two-year-old pine tree when you're showing the picture to friends at home? Your brain needs a point of reference - something that's a size you're already familiar with. That gigantic mountain could just as well be a molehill, if you don't have anything to compare it with. However, if you place a person, car or something else in the frame that has an immediately recognizable size, you'll provide a completely different sense of perspective.

A gaunt man led his two cows between palm trees as tall as five-story buildings. The sun, just rising over the Gulf of Thailand, made it look like the whole beach was exploding in a cloud of sand. It was morning in the small and at the moment very tired town of Ban Nai Plao. On the streets men were walking towards the forest with their monkeys to pick coconuts before the sun got too hot to stand.

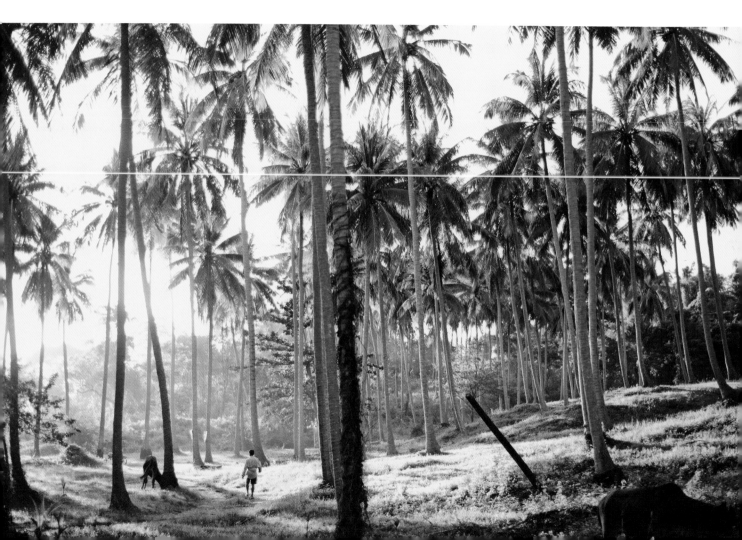

4

GET UP THERE!

One of the goals of a travel photographer is to show viewers a place from an angle they haven't seen before. While everyone else is busy walking through a city's streets and alleys, take a moment to look up. Where can you go to get an overview of the city? How far up can you go? When taking pictures from above, you're elevating viewers to a place they probably wouldn't find themselves. Find the highest point in the area and go there.

Half an hour earlier, I had taken the stairs up to the roof of the cathedral in the middle of Piazza del Duomo. Now I was just waiting for the right light. Tourists on manic shopping sprees were walking from store to store under the large cupola covering the Galleria Vittorio Emanuele II. The saints were balancing on their stone pillars surrounding the cathedral. I watched the dome's white light spread into the approaching night, showing Milan at its most beautiful.

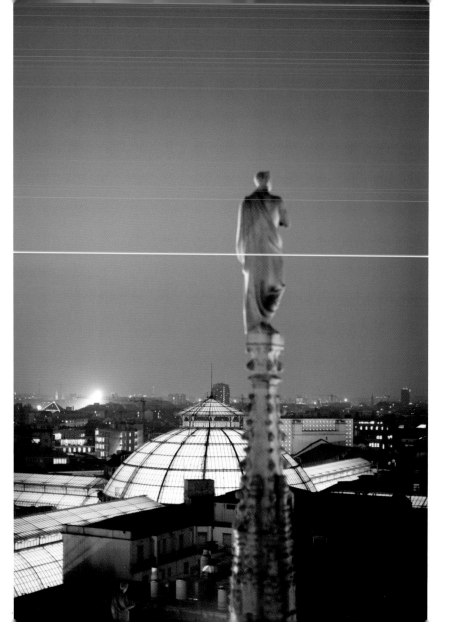

5

HIDE IN PLAIN SIGHT

You're bound to be noticed as soon as you arrive in a new place. But the longer you stay in the same location, the less attention you'll attract. You become a part of the scene; part of the environment. Everyone will be less aware of you and the fact that you are taking pictures.

Don't rush away from a good photo spot. Hang around for a while until you become a fly on the wall and it will be easier to capture the scenes in front of you. You and the people around you will feel increasingly comfortable with each other.

A month-long trip around Sri Lanka was coming to an end. I stayed at the gigantic colonial Galle Face Hotel in Colombo. A very narrow strip of beach, no more than ten feet wide, stretched for miles alongside the stone wall. During the day it was empty, but when the sun was about to set, thousands of Sri Lankans gathered to play in the waves. I was amazed by the light and the scene and came back evening after evening. I walked around among the families, couples and laughing children until the sun was nowhere to be seen.

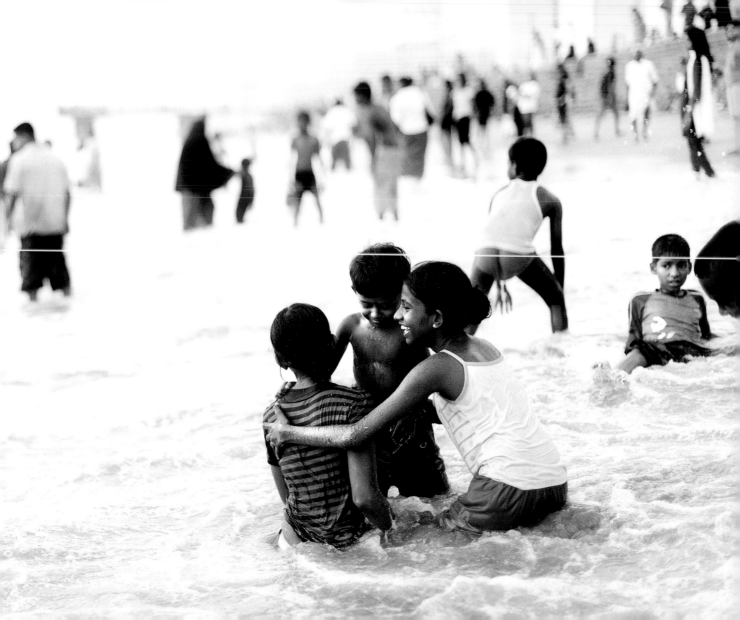

6

IT'S ALL IN THE DETAILS

Renowned photographer Robert Capa once said, "If your photographs aren't good enough, you're not close enough." Even though you should take this with a grain of salt, keep the old master's voice in the back of your mind. A photographer isn't supposed to capture everything in one frame, just the interesting parts. Don't forget to look really closely, because you might find a completely new world. Get as close as possible and capture the smallest details.

I'd been walking back and forth on a sandy road, looking for the path that was supposed to lead into the jungle. An old couple had been watching me and when I passed for the fifth time they waved for me to come over. They were sitting on a wooden porch in front of their small house. They didn't speak a word of English and I certainly didn't have any skills in Thai. Nevertheless, we spent a couple of hours together sharing lunch, bananas and a weird orange fruit that I actually thought might kill me for a couple of white-knuckled minutes. I survived though.

7

THE KIDS ARE ALL RIGHT

Children are the most amazing models there are. They don't worry about what they look like or if they are beautiful enough to be in a picture. They don't care about behaving. They won't judge you; they won't laugh at your silly attempts to speak their language. They are inspiring to be around and everyone could, and should, learn from their curiosity. Spending time with kids is a sure way to bring home honest and intimate portraits.

I was walking through miles of green tea plants when tiny raindrops started to soak into the sandy road zigzagging towards the top of the hill. A group of kids had been following me from a distance for almost an hour, hiding in the leafy ocean of Sri Lanka's greatest export. Suddenly they dared to come closer and a few moments later it was nearly impossible to take a picture without at least one laughing boy. The second I raised my camera, my viewfinder was filled white-toothed smiles.

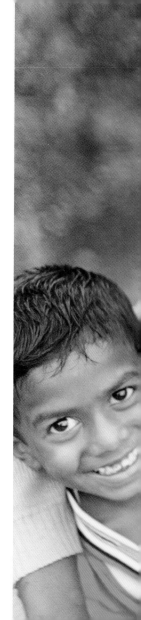

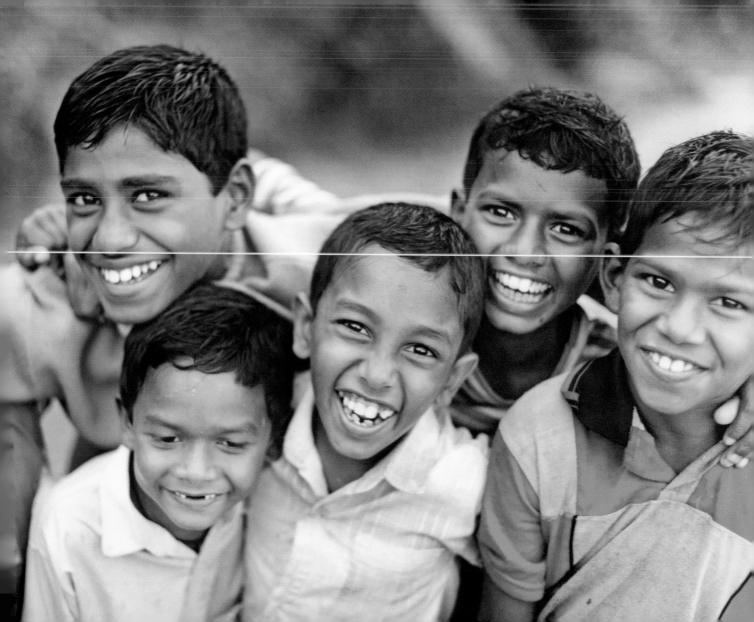

BACKGROUND CHECK

There are generally three main layers in every photograph: the foreground, the subject and the background. The latter could make your picture pop or flop. Before you press the shutter, take a moment to think about what the background look like. The camera transforms three-dimensional reality into a two-dimensional picture and if the background is not thought through, it can ruin a great shot. Pay attention to what's behind your subject.

I saw it from far away. The old, two-colored American car and the wall behind with the exact same colors, only inverted. It was so perfect I almost thought the driver had been aware of it and parked his car right there, just waiting for an attentive photographer to walk by. Sometimes the world's colors come together in amazing ways. Pay attention to color schemes and you'll be able to get great pictures.

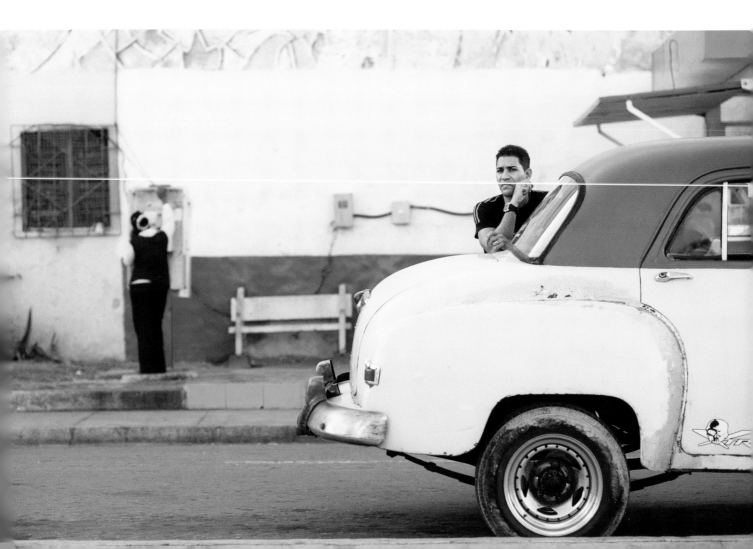

9

A PICTURE SAYS MORE WITH A COUPLE WORDS

I'm sure you've heard the old saying about a picture and a thousand words, right? But why don't we mix pictures and words? Employing words and sentences to enhance the story can be a very powerful technique. Look for street signs, restaurant menus and walls filled with graffiti to help you get your message out!

I'm not sure if the man was actually rewriting the restaurant's menu, but it sure looks like it, doesn't it? It was a chilly day in Dharamsala in northern India and I was walking down the main street, trying to find a place to eat and warm up enough to get the blood flowing in my hands again. At first I walked past him, as I was just too hungry to pay attention. But something made me stop and go back.

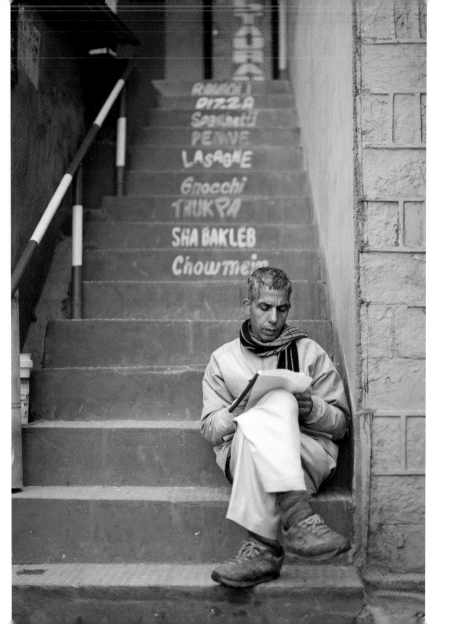

10

GO WITH THE FLOW

Don't think too much. Just let things happen. Turn off the part of your brain that is constantly trying to figure out what's going to happen next. Let everything that happens lead to something else. Don't try to stop it. If you love to plan your trips, please do. But leave some time for the natural flow of things to show its beautiful face.

About an hour earlier I was woken from my slumber in the back seat of a white van that was driving to northern India. I felt a force pull my entire body towards the front seat as the driver brutally hit the brakes. A split second earlier I had heard his terrified gasp when he realized that he wouldn't be able to steer away from the oncoming red motorcycle. Now I was sitting in between eight Tibetan monks heading for Dharamsala in an exact replica of the van that had just crashed. They'd stopped to pick me up. I hung out with them for the rest of the day and accompanied them on one of their many pilgrimages. We didn't share a language, but we shared food and company.

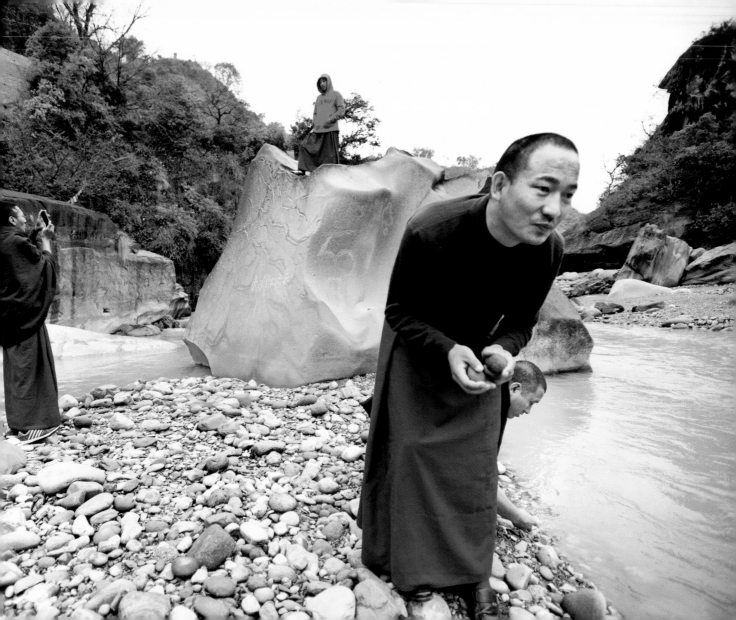

11

GET BACK

A great portrait does not require a single face within the frame. By capturing strong body language or a distinctive posture, a person's back can be just as interesting. In this kind of picture, the focus is usually on what the model is facing. It's like showing a movie screen and the person watching the film. Sometimes, portraying a person from behind can give you just as much of a story as if they were facing you.

This tiny girl's family was standing in ankle-deep water on the beach in Colombo, Sri Lanka. She was gazing at the boys playing a short distance from her, but every time she tried to join them her mother would call her back, afraid that she would get caught in the current. The beach was filled with other people but I chose not to include anyone else to enhance the feeling of solitude.

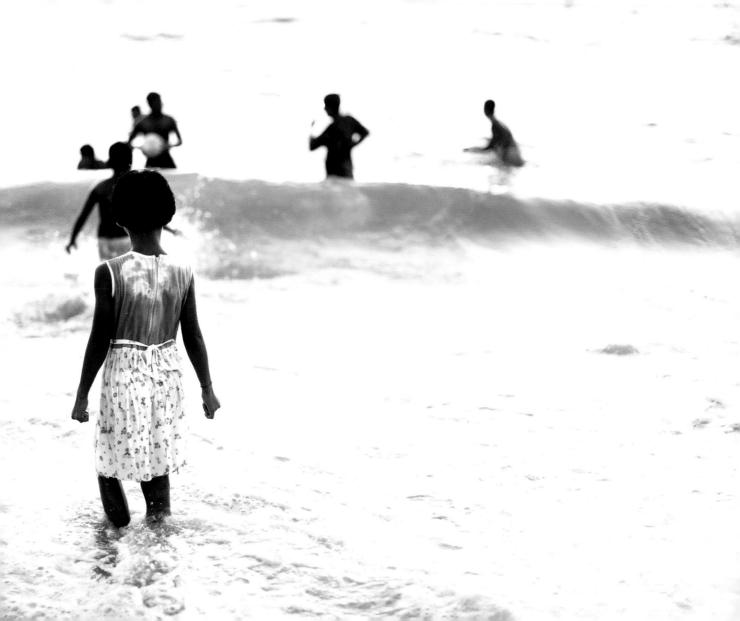

12

STAY OUT AFTER DARK

Taking photographs means painting with light. But don't forget there is plenty of light to paint with even after the sun is long gone. A whole new world opens up when day flows into night. People transition from work to leisure or the other way around. When the tourists put their cameras away after shooting the sunset, keep yours in your hands, ready to explore the nightlife.

This food-filled alley didn't make much of an impression during the daylight hours. But when the sun was finally gone, oily cooking fumes started to waft through the air and the fluorescent tubes showered everyone in cold, blue light. Dough was fried in gigantic black woks and sold for a couple of cents, wrapped in thin, white paper. The dogs waited patiently for a serving without moving a muscle.

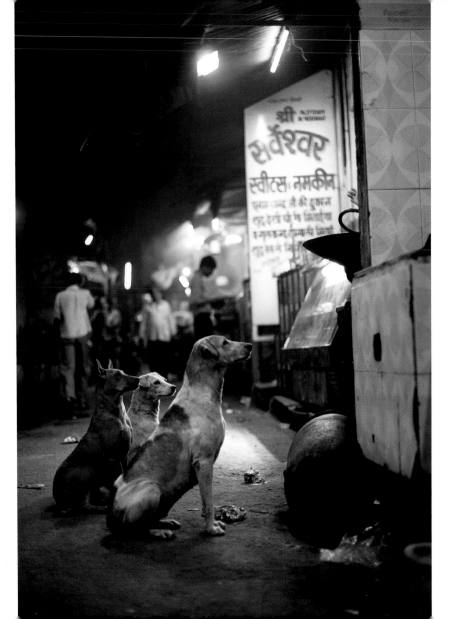

13

PATIENCE IS A VIRTUE

We live in a world where everything needs to move quickly. We need fast food, super-fast internet connections and express trains. But if you're a photographer, you must forget the need for speed. You need to be able to wait to get that picture, maybe by staying in the same place for hours at a time. Because when you finally capture it, that photograph will last forever.

In the center of Old Havana, a lonely trumpet player sat on the sidewalk, letting smooth tunes float towards the balconies above. The moment I got there, a class of schoolchildren passed right behind him. Before I could get close enough to get a shot, they were already gone. My intuition told me they were coming back, so I sat down across the street under a big tree. While I waited, I watched a young police woman arguing with two men with a dog. An hour and a half later, I caught a glimpse of something red out of the corner of my eye. It was the same class, heading back to school.

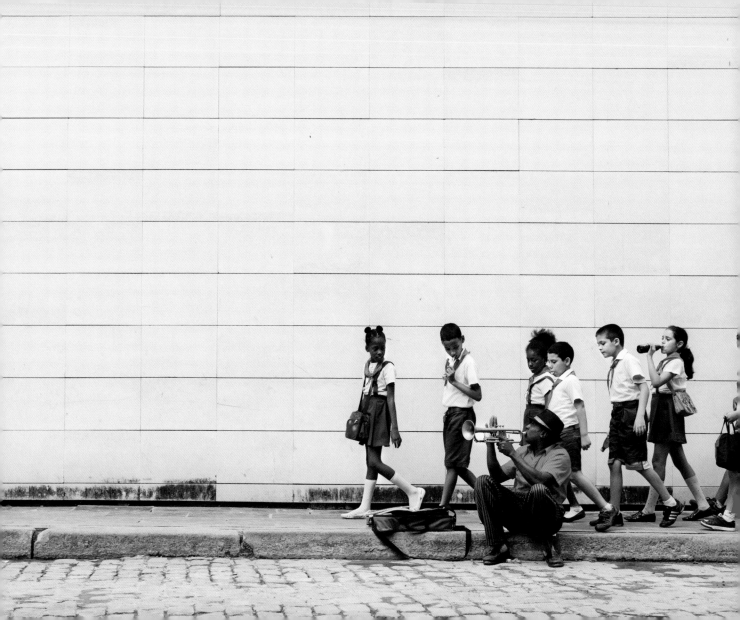

14

DON 'T FORGET TO TRAVEL WHILE TRAVELING

Do you tend to "shut down" while sitting in a bus or flying over an ocean in a crowded jet? Look around! The people sitting next to you have each experienced as much as you have. Maybe they've traveled the globe twice and can give you endless ideas for your next trip. Or maybe they have advice that will change your life. Don't zone out just because you are currently going from one place to another.

I captured the photo of this exhausted boy on the bus from Dharamsala - the refuge of the 14th Dalai Lama. I met David right after - a 60-year-old man from Oregon who claimed (and I believed him) to be responsible for the chai tea boom in America. Over the long hours bumping down narrow serpentine roads, we talked about Saturn Return, hallucinogens and relationships.

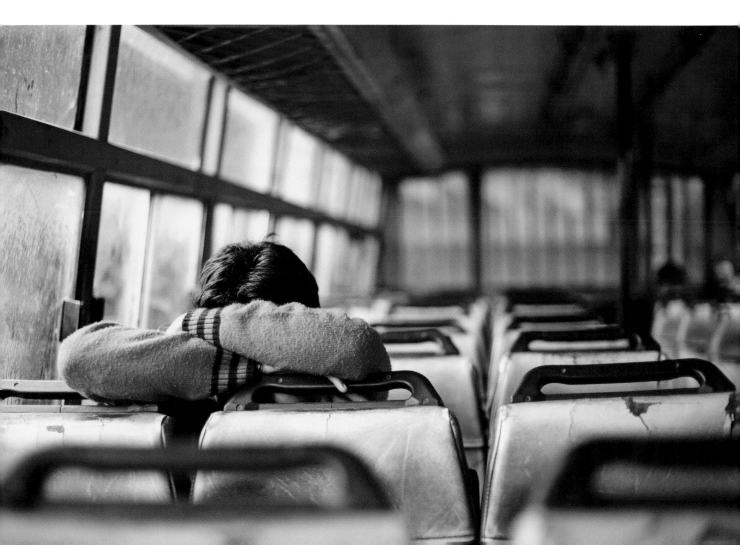

15

WHERE ARE YOUR FEET?

Sometimes we make it too complicated, trying to find subjects in the most difficult places. Once in a while, look down at your feet. Sometimes they'll tell the best story about where you are right now. Show your trip by documenting where you put your feet.

During a recent press trip to Barbados, I was walking on one of many beaches on the island. The sun was hot as hell and my skin already looked like a well-cooked lobster. I took shelter under a tiny palm tree on the beach. The cool, salty water washed over my feet.

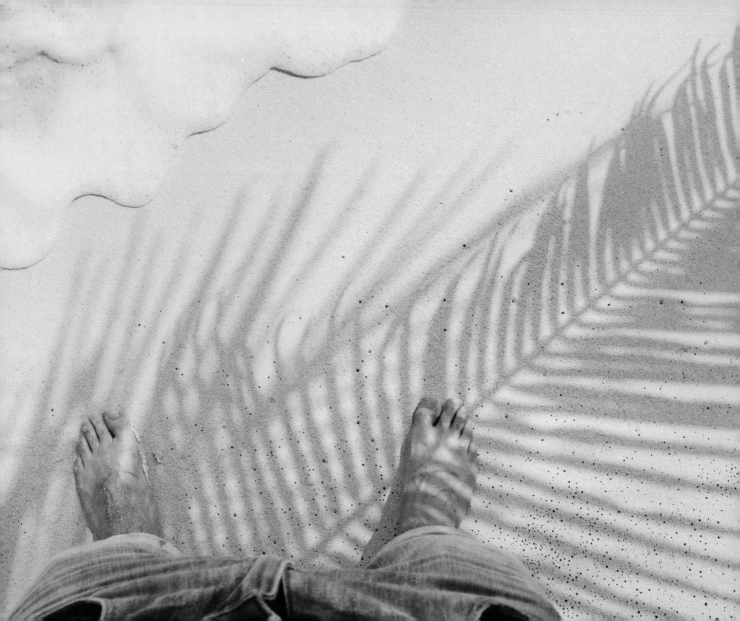

16

CLUTTER CONTROL

I usually like to keep my pictures clean and uncluttered. But sometimes, when the opportunity presents itself, I do the complete opposite. By using a lot, almost too many patterns and colors, you'll be able to compose a very interesting picture. The eye needs a couple of seconds to comprehend what is happening.

In the western Indian province of Rajasthan you'll find a small city named Pushkar. This holy city is a web of tiny, dusty alleys and there are small shrines everywhere for the thousands of gods that need to be worshipped in India. It was early morning and many people stopped for a couple of seconds to pay their respects to the icon in the shrine.

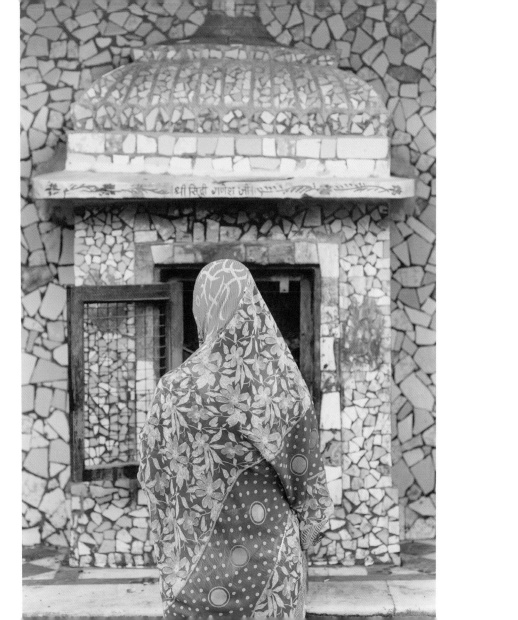

17

BREAKING AND ENTERING

Most of us have a fear of disrupting other people. We don't want to bother them any longer than we have to. But getting the best shots requires you to interact with people on the street. Fight the evil little voice in your head telling you not to take up too much of a stranger's time. If you're persistent, you'll discover the most authentic parts of the country, learn about traditions and find new spots. If you show interest in someone's life, you'll be surprised how often you're invited into the home of a new friend. And trust me, there's no better place to taste the country's best food!

Among jewelry and incense salesmen on the main street of Pushkar, India, a bearded man sat with his eyes glued to a white canvas. All around him, paintings were hanging on the walls. He introduced himself as Kikasso, Pushkar's self-declared Picasso. Every day he sat in his corner painting for hours, almost without noticing the people passing by. After talking to him for a while, he invited me to his home, a ten-minute walk from where we met. We spent the afternoon drinking chai and going through his vast collection of art books. He was constantly smiling.

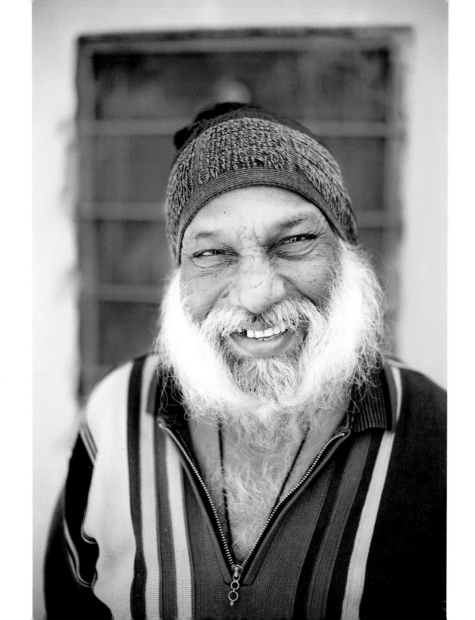

18

TURN OUT THE LIGHTS

There is something called "correct exposure", but I think this concept can be pretty deceptive. If you let your camera decide what the correct exposure is, you'll sometimes end up with a picture that is far too bright. The camera has no feeling for mood and it will surely ruin a lot of beautiful scenes by choosing the wrong shutter speed. Try to underexpose scenes to capture a dark or calm feeling.

If you walk under a green concrete sign in Nuwara Eliya, you'll enter the elementary school of this dusty city in southern Sri Lanka. Right inside the gate, hundreds of young kids played their country's national sport - cricket - dressed in white pants and red woolen sweaters. On the field next to the school, a group of military men participated in a marching drill. When I was about to leave, I found a small door leading into the dim, hangar-like hall where a basketball tournament was being held. On the terrace I met this little boy and his big sister.

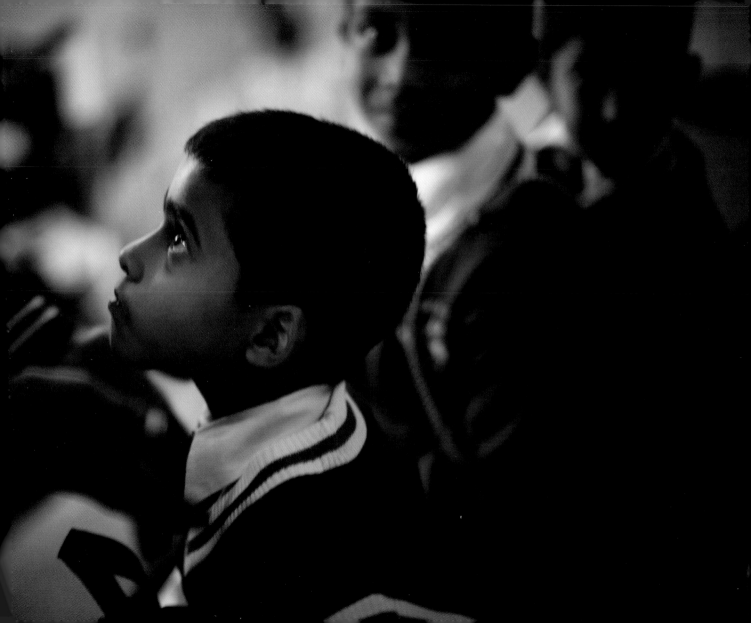

19

SMOKE GETS IN YOUR EYES

Cigarette smoke, cooking fumes, burning incense. I'm constantly keeping an eye out for those swirling, magic movements. They create amazing abstract shapes and make wonderful pictures once you know what to look for. You'll get the best results if the smoke is between you and the light source.

The walls around the small door in the centre of Havana were filled with all kinds of painted objects. The interior consisted of one large room, its grey concrete walls crammed with illustrated canvases. I met Johnny, the 22-year-old artist with nothing but painting in his heart and Tony, the former English teacher who was selling the pictures to the tourists that sometimes wandered in. I returned to the gallery many nights after that to drink rum out of up-cycled PET bottles and talk about Havana and its art.

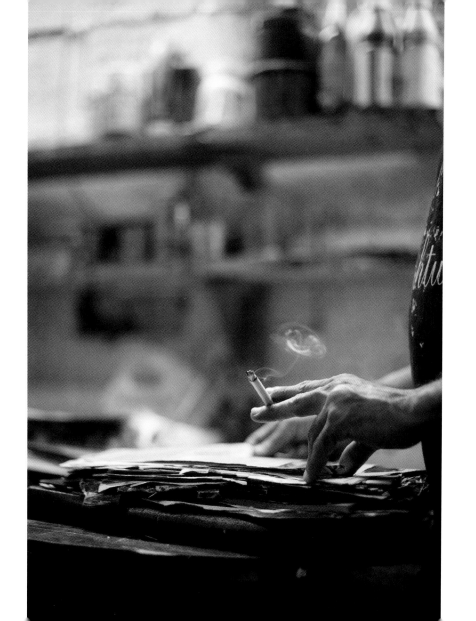

20

COLOR COMPANIONS

Complementary colors are the colors found on opposite sides of the color wheel. Red and green, violet and yellow, and blue and orange look very striking if you put them in the same frame. Learn which colors work well together. You'll get the best effect if you include as few other colors as possible.

These bright orange beach chairs were located in front of a gigantic hotel complex, a very common sight on the coastline of Barbados. Usually I try to stay away from these types of locations, as there's something about obese, reddish tourists that I just can't stand. But the nice set of beach chairs at this particular hotel played very well off the blue sky, so I decided to stick around for a while.

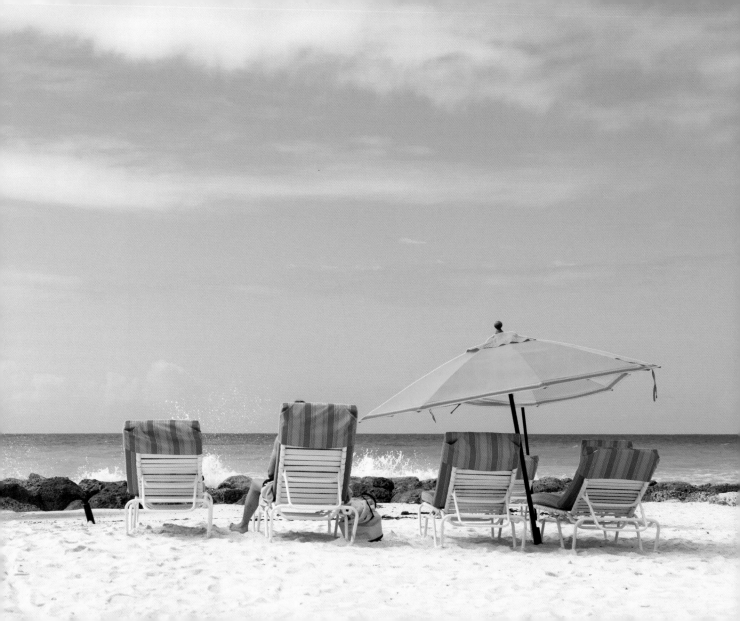

EXERCISE 1: JUST DO IT

If you look through some articles shot by your favorite travel photographers, it's likely they'll have one thing in common: great portraits. Travel photographers must have the ability to get close to people and make them relax. Intimate portraits build an instant connection between the location, the story and the viewer. It's often one of the last skills you'll master, if only because it's frightening to approach total strangers on the street.

This exercise will teach you to:
• Talk to strangers on the street
• Stay calm during the shot
• Improve your street portraits

STEP 1

Find a photography buddy and take a walk in a fairly crowded area, preferably where people don't just rush by. A location where people naturally take a break is ideal, like a park, market or train station. As you get more experience, you'll be able to take portraits even if the person is in a hurry, but let's make it a little bit easier to start.

STEP 2

Keep your camera easily accessible, around your neck or over your shoulder. Take turns with your buddy picking out interesting faces. Your buddy should find a suitable model for you and point him or her out. When he does, you have to approach that person immediately, without thinking. If you hesitate, your buddy should encourage you to do it, first by reminding you and then by literally pushing you in the right direction if necessary.

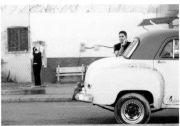

Approach your model without acting like you have anything to hide. It's important that you actually believe you aren't doing anything out of the ordinary. Make eye contact and approach your target with confidence. You may want to discuss your opening line with your buddy in advance. You could simply say, "Hi, my name is Jens. We're practicing taking pictures of strangers. Do you mind if I take your picture?" The truth is good enough. You're a photographer, not a secret agent.

If your potential model says yes, feel free to ask him or her to move slightly. You might want to decide on a suitable background before you approach so you'll have one less thing to think about. Remember, you now have permission to take a few minutes of their time. Don't rush it and try not to feel stressed. Ask yourself, "What is the worst that can happen?" Someone might say, "Sorry, but I really have to go now." Keep going until you are satisfied, and then thank your model for their time.

Afterwards, discuss with your buddy what went well and what went wrong. Also, review your pictures and see if there is anything you could do better next time.

Approaching people you don't know is enormously challenging if you are not used to it. Working with a buddy makes everything less frightening. It's a difficult threshold to cross, but it pays great rewards once you've mastered the skill.

21

BLURRED VISION

By setting your aperture to the smallest value you'll get a very short depth of field. That means, for example, that the part of the face that you are focusing on will be very sharp and everything closer to or further away from the camera will be blurry. This is one of the few tips that partially depends on your equipment. The lower aperture value you're able to get, the greater effect you'll see. The blur could save a picture from an otherwise messy background.

Three minutes before this picture was taken, I drank warm goat milk out of a plastic bottle. Two minutes before that, the milk was still in the goat. I had driven to a small Indian village on a Royal Enfield motorcycle, on sandy roads with mountains rising towards the sky on both sides. The man in the picture is the head of that village, Satari City.

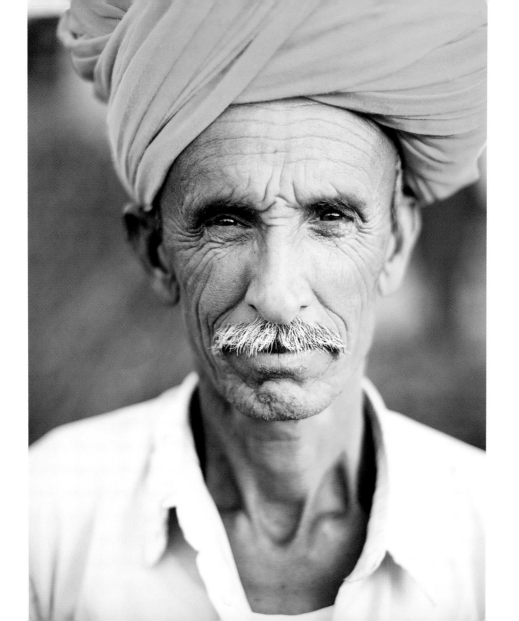

22

SILHOUETTES

A very interesting way to photograph people is by only showing their silhouettes. While the background is correctly exposed, the people are totally black. Measure the light on the background (a well-lit wall or sunny sky) and you'll get a dark, sharp silhouette.

These jellyfish, as large as basketballs, were floating around one of the dozen tanks containing similar slimy creatures at the Monterey Bay Aquarium in California. The light outside the tanks was dimmed and I could easily stand for half an hour in the dark to capture the right moment. Even though she's totally in the dark, you can still perceive that the woman in the middle is holding a camera.

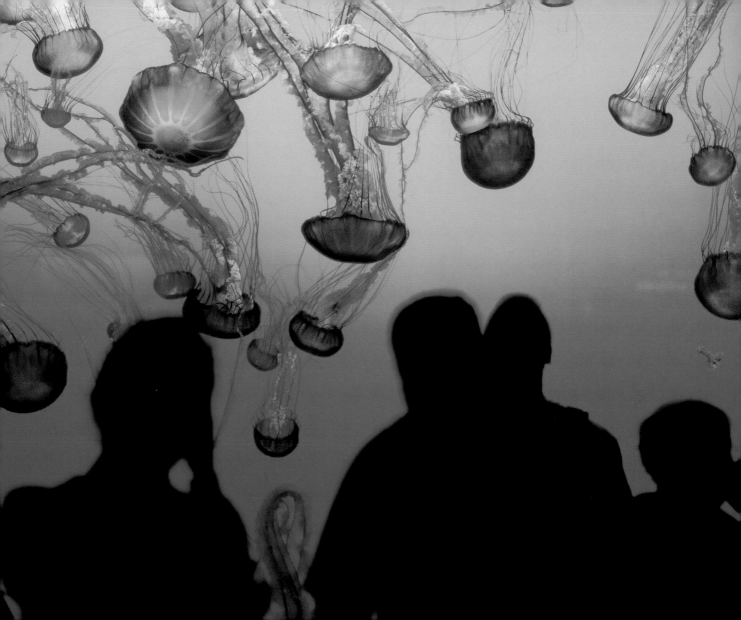

23

GET AHEAD OF YOURSELF

A good photographer is able to see an interesting scene as it is happening. A great photographer is able to anticipate what will happen thirty seconds later. By reading body language, tone of voice and the direction someone is facing, you're almost able to read their minds. It will take some time to get to the point where you can "predict the future", but take it step by step. Start by just paying a little extra attention to people and how they move and talk. Soon, you'll realize that a group of people is about to laugh, five seconds before they actually do.

The city of Jaipur, India was just waking up when a Spanish pilot filled a gigantic balloon with hot air. It slowly rose from the ground until it was buoyant enough to take him and four British women off the ground. The rest of us followed in a Jeep, trying to figure out where the massive object was going to land. The car stopped so that I could take some photos. Something huge passed behind me and I turned around to face an elephant the size of a small house, on his way to work. Rushing, with my camera tightly in my hands, I passed the animal and stopped twenty-five meters ahead of the procession. I aimed for the floating balloon and waited for the big animal to walk into my viewfinder. Click.

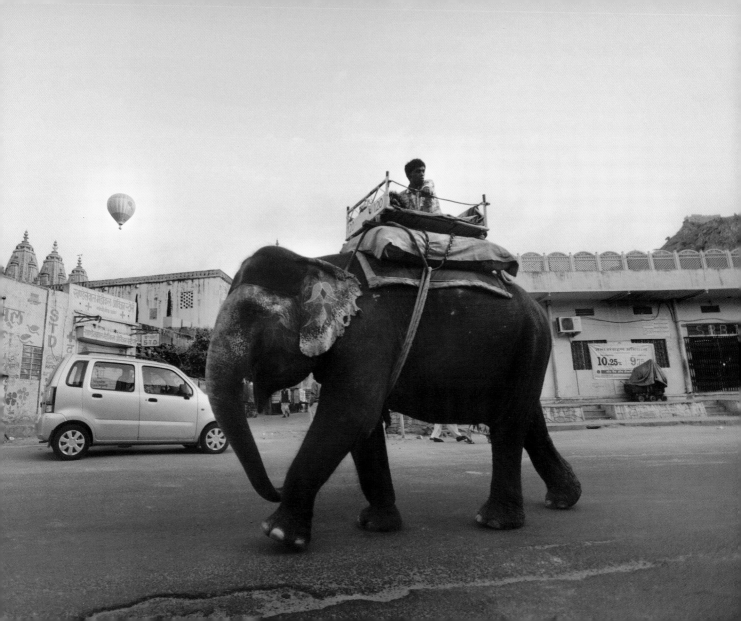

24

MY GOLDEN RULE

The most common reason for missing great shots is being too afraid to ask someone's permission to take their picture. Your mind will come up with millions of reasons why you shouldn't ask. There will be a better opportunity further down the road. The light isn't right. You're hungry. You're stupid. I have a rule that I've promised myself to always follow. Whenever I think "Oh, that's an interesting/beautiful/weird person/scene/thing", I have to do everything possible to get the shot. And that includes daring to ask permission. Follow my rule and I promise you'll get loads of great pictures, and you'll never again have to regret not trying.

Close to the Adige River in Verona, the hometown of Romeo and Juliet, a waiter walked out of a restaurant. His spotless black and white uniform caught my eye as I was walking by. The sidewalk was packed with small black tables occupied by hungry lunch guests. My feet kept on walking for a few meters because my brain told me that the waiter was probably too busy serving food. Then I remembered my rule, turned around and walked up to him.

25

IT MATTERS IF IT'S BLACK AND WHITE

As a photographer, you have the opportunity - or even the responsibility - to show your viewer where to look. You need to tell them where the important stuff is. There are a lot of ways you can accomplish this. First, you should eliminate all unnecessary distractions. Converting a picture to black and white is one way of doing just that. You don't have to think about the colors, because the only thing left is lines and shapes.

This is Tony, a former English teacher that became an art salesman in Havana. He was one of those people that you could take a thousand pictures of and every single one would turn out well. With colors, you wouldn't know where to look in this picture. Your eyes would linger on every painting, every nuance. It would take a while to even find Tony. When I made the picture monochromatic, all the distractions disappeared.

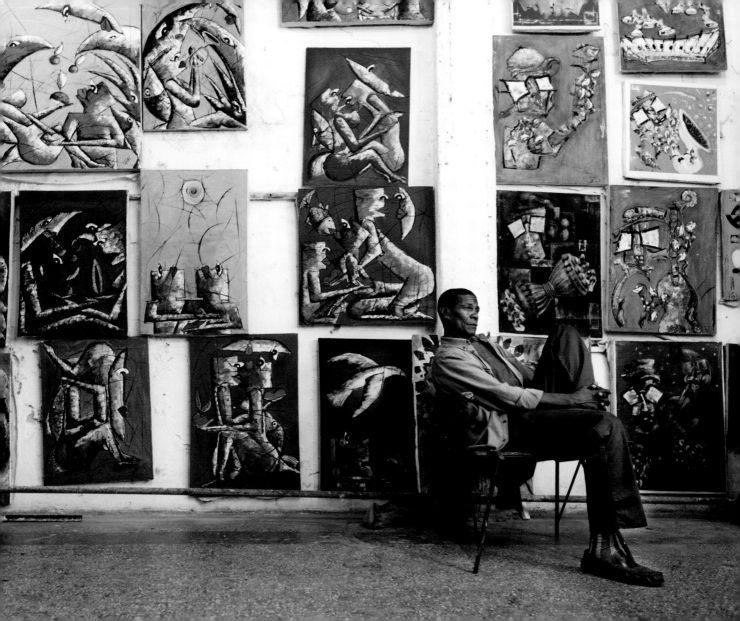

26

NOT AS BAD AS YOU THINK

Besides how many megapixels a camera has, how little image noise high ISO produces is one of the camera salesman's best pitches. But you can let that noise work for you. It could give your picture a new dimension or tell the viewer about the rugged environment where it was taken. So crank up the ISO and let that fantastic digital grain trash your picture like it was 1969.

The walls around me displayed the work of some of the most talented graffiti artists in New York City. We were waiting for an independent documentary about the world's strongest man to roll on the screen. Beyond the chicken wire that prevented people from throwing stuff from the 15th floor, the city started to come to life under the shifting sky.

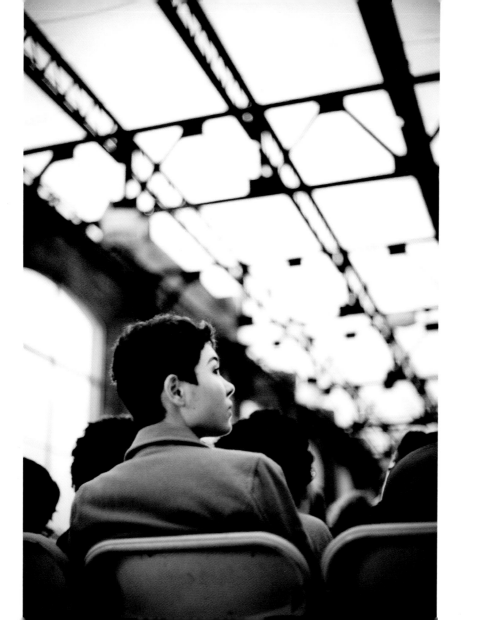

27

BE SQUARE

Put another frame within the natural frame that your picture itself creates. This is another way you can give the impression that some parts of the picture are more important than others. Look for windows, doorways, holes and anything else that could frame your shot.

About a hundred meters from here Cuba's national hero, Che Guevara, got married under the blue sky. These teenage boys were playing football on the small square in Casa Blanca on the outskirts of Havana. I had to duck a few stray projectiles that were unintentionally kicked in my direction.

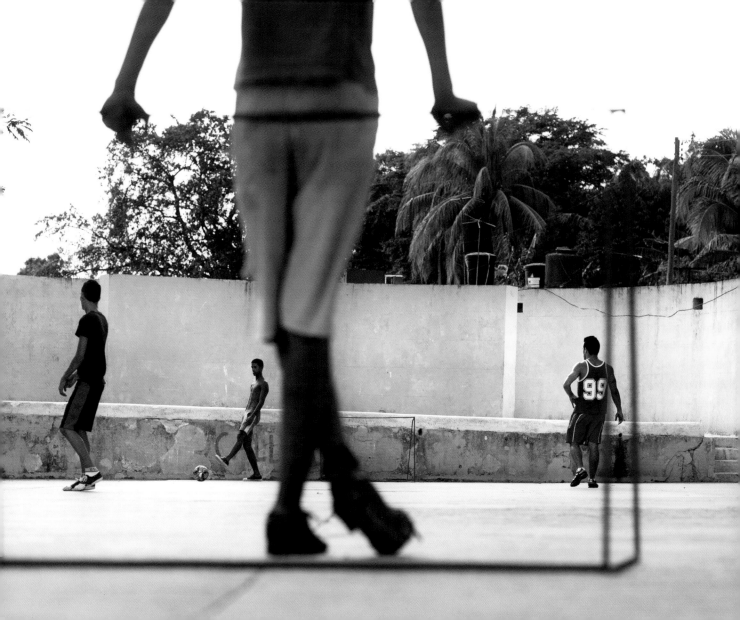

28

HEY, TAXI!

If you're in a country where it's affordable, rent a car with a driver for a couple of days. Not only can you stop wherever you like, you'll be able to get lots of information about where to find what you're looking for. For the money you'll spend, you'll be rewarded with loads of photo opportunities. It's a great way of getting to know a place and its people at your own pace.

Lucky. For five days he drove me back and forth on the island of Sri Lanka. He found the best deals on hotels, told me where to eat genuine Sri Lankan food and pulled the car over whenever I found a view worth photographing.

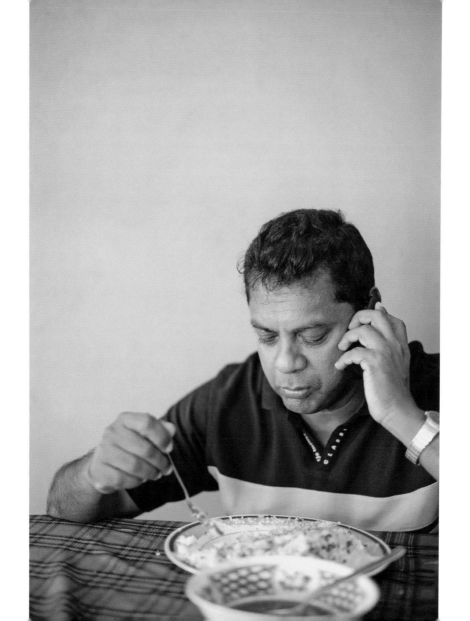

29

ASKING THE RIGHT QUESTIONS

If you are traveling in a touristy area and ask someone "Where can I find a good restaurant?" there's a good chance you'll get directed to places in the city center where locals never set foot. Try "Where do YOU like to eat?" instead. It's a tiny adjustment, but it will help you find the authentic spots that serve the really good stuff. It's all about how you phrase it.

Mario took a break from playing his barrel organ to tell me about how it was passed from his grandfather to his father and then finally to him. He told me how he left Verona for a couple months each year to play in big cities around Europe. And he told me where I could find the best *aperitivo* in town.

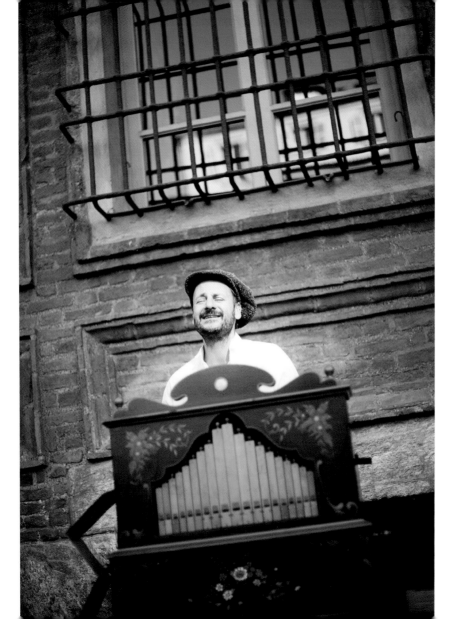

30

THE FORGOTTEN CITY

Airports are boring. At least if you view them the same way everyone else does, as a place where you wait for a plane to take you to a warm, sandy beach. But when you start to look at airports as tiny cities with thousands of inhabitants, things start to get more interesting. Instead of spending the whole time eyeballing exhausted tourists at the gate, take a walk. There is plenty to photograph at any airport you'll visit.

Flying fish is the national dish of Barbados and you won't be there long before someone asks you if you've tried it yet. The airport also had its share of the tiny fish. The funny thing is, they're not that spectacular. They don't taste amazing. And they don't really fly. At least not very well...

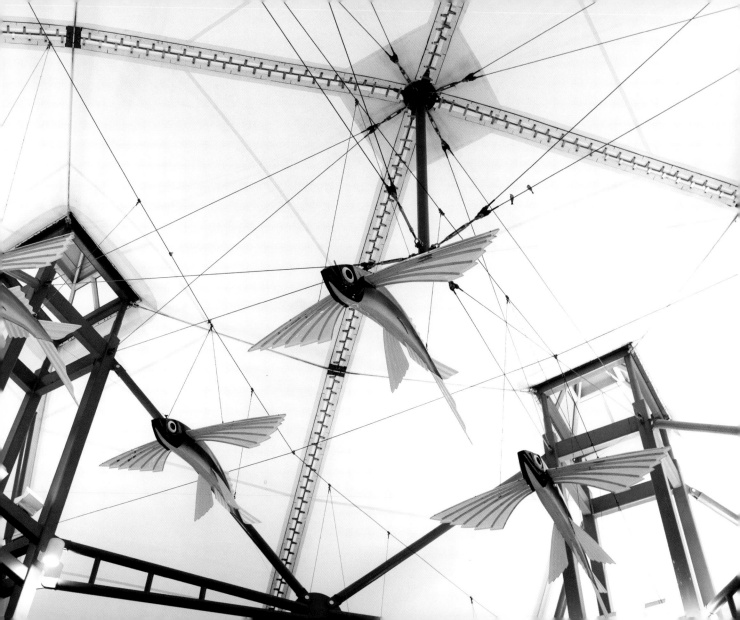

31

MIRROR, MIRROR...

Puddles, car windows, sunglasses, mirrors. Whenever you use reflections in your images, you'll mess with people's heads for a moment. We are not used to seeing the world backwards. So take a look around. What can be used as a mirror?

I really hate all-inclusive vacations. The whole thing is as far from authentic as you can possibly get. So when I occasionally end up in such a hotel complex, I need to get creative to avoid losing my mind. I was walking around one of the hotels in Sharm El Sheikh, Egypt when I started experimenting with the reflections in the pool. A not very interesting place just got a bit more interesting.

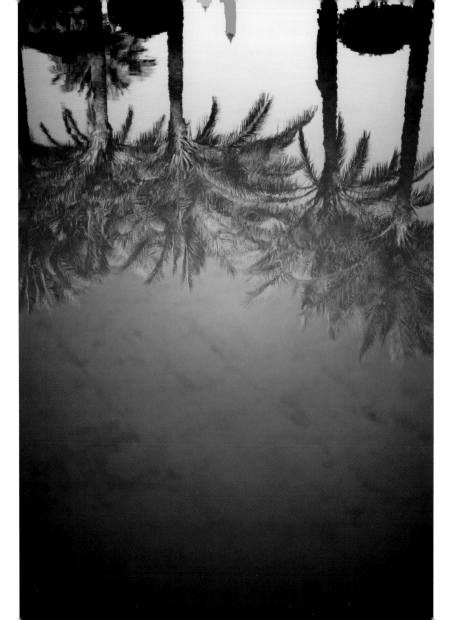

32

ON THE MOVE

In the words of English writer William Hazlitt, "Everything is in motion. Everything flows. Everything is vibrating." Every picture is a tiny moment frozen in time. That doesn't mean that it can't show motion. Pay attention to the shutter speed on your camera - it's one of the best ways to show motion. Use a shutter speed that is long enough to give you the motion blur but short enough that the camera won't register the shaking from your hands.

The old man had been driving his bicycle rickshaw for over 40 year on the streets of Jaipur, India. He threw his bike in front of cars and trucks, without the slightest sign of hesitation, to get me to the bus station on the other side of the town. I was not as fearless. Keeping my eye glued to the viewfinder helped lower my heart rate.

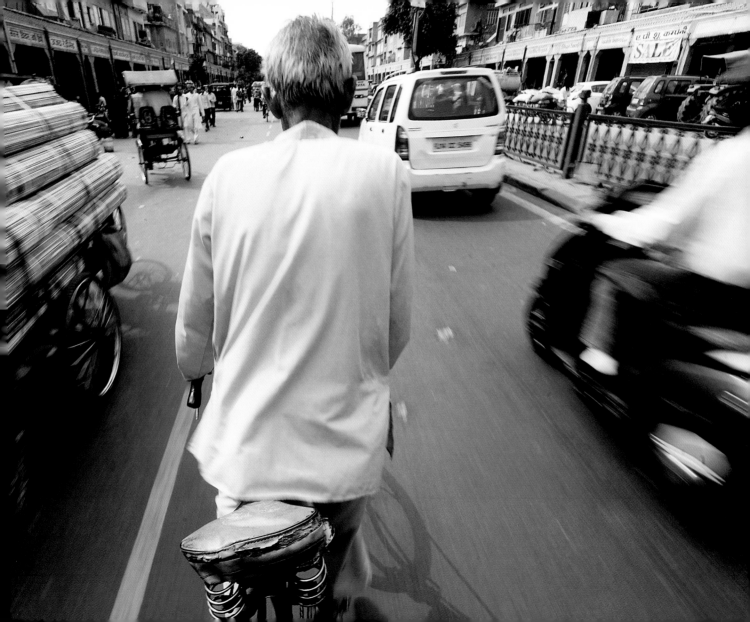

33

LOSE YOUR HEAD

What is a portrait? Do you have to show a person's head for it to count? The eyes? Do you have to show a body at all? Can a picture of a shadow still be a portrait? Instead of doing the usual face-forward-looking-at-the-camera-thing, shoot the most interesting part of the person. Use your imagination. You can decide what to call a portrait – there's no right or wrong.

In Budapest, you'll find dinner fit for a knight. Sir Lancelot serves up the best medieval food on the planet. You (and at least three friends) can order a wooden platter the size of a large sink filled with the tenderest meat you'll ever taste. If you ask for a fork, the busty barmaids will raise their eyebrows and answer with a definitive "no". Eat with your hands, medieval style, and wash it down with a pitcher of beer. I was photographing a bodyguard academy on the outskirts of the city, and one night we visited god's gift to meat-loving man.

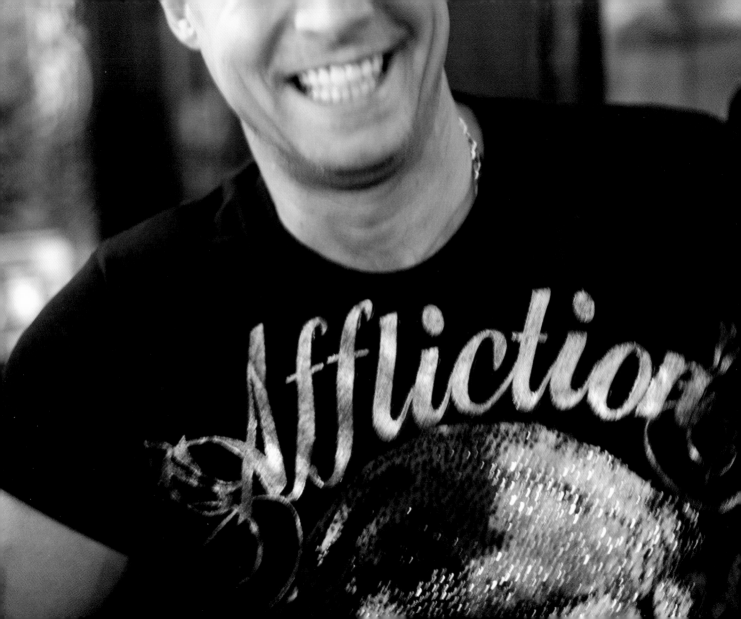

34

HIGH AS A KITE

There's a reason "being able to fly" tops the list of most-wanted super powers. We love the feeling of freedom, being able to look down on everything and everyone. But you don't have to get as high as the clouds to take a picture. A few stories or even a few feet above the ground is good enough to change your perspective. Look up, find a spot and get up there.

This picture of the taxi was actually taken from the same place as the very first picture in this book. A rooftop cinema, set up for that night. I pushed the magenta colors a lot, actually by accident, during post-production. Suddenly I got the exact same feeling as when I hung over the edge of that roof.

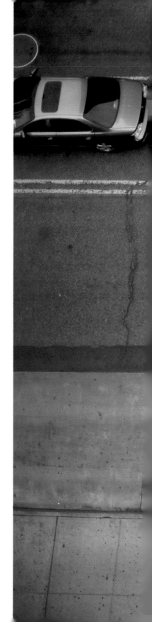

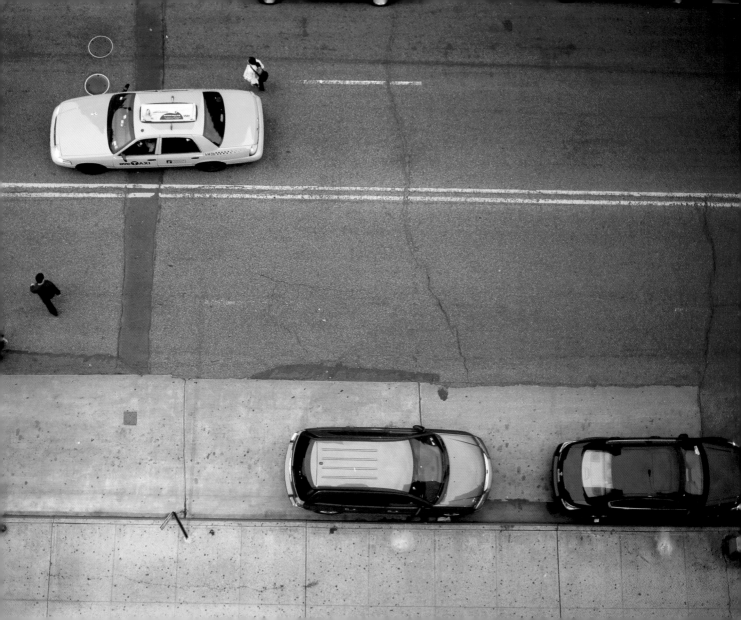

35

JUST A LITTLE BIT

Sometimes you'll be able to tell a person's whole story using only a tiny detail of his or her body or clothing. Like a special necklace, a scar or a weird haircut. As a photographer, your goal is to create a narrative, but you don't have to show everything. So zoom in a little bit and dare to focus on the details.

The title of the previous tip suits this picture perfectly. This guy was stoned. Every night a group of young people gathered on Venice Beach in LA. They were singing, dancing and playing music until sunset. They would have continued for most of the night if it weren't for the half-dozen police cars lined up a short distance away, waiting for the curfew to kick in. The cops had just stopped the fun with their sirens and everyone was on their way to find the next party when I saw the poetic tattoo on the skull of this slightly edgy guy.

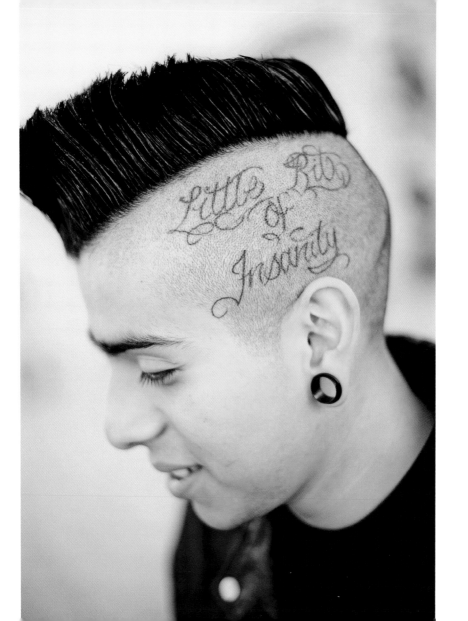

36

LIGHTS ON!

A lot of the tips in this book incorporate the light around you. Lighting is the essence of photography and the most important thing to pay attention to. Look for different types of light at different times of the day. Observe how the light and shadows create amazing shapes. Learn how light plays. Then play with it.

We took shelter in a cave when a warm rain started to pour down. Scorpions and snakes, both pretty harmless we were told, kept us company. I wasn't so sure though, as Thai people have a nasty habit of telling you what they think you want to hear. I survived. Take a look at this photo of our guide. Can you see the faint light on his chin and mouth? Together with the illuminated smoke it outlines the features of his face perfectly.

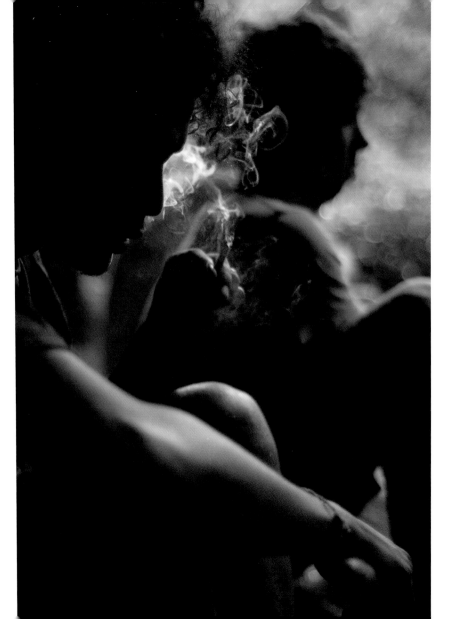

37

CLEAN IT UP

Want to know one of the most efficient ways to get better, more interesting pictures? It's certainly not by adding components to the photo. Instead you should do just the opposite and try to remove as much as you can. Clean it up. Go as minimal as possible and exclude everything that does not add something to the picture.

Malecón. Havana's eight-kilometer boardwalk is the most interesting place in the city to watch the sun retire at the end of the day. At sunset the big wall stops being just a wall and becomes a bar, stage and dance floor. I was once told that the only thing you need at Malecón is a girlfriend and a bottle of rum.

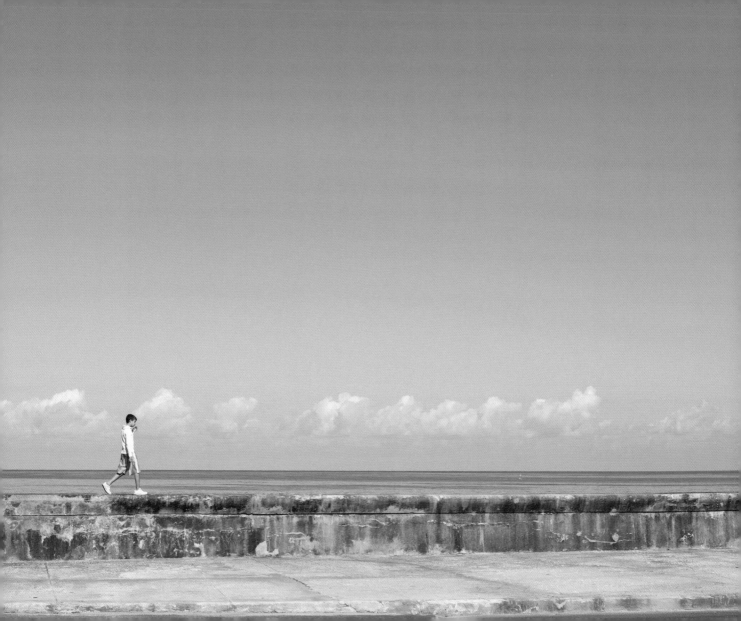

38

WHO'S PHOTOGRAPHING THE PHOTOGRAPHERS?

You can't ignore us - we're often part of the landscape. And by we, I mean photographers. Sometimes really funny situations occur when lots of people want to take pictures of the same thing. If you turn your camera towards the people taking the pictures instead of photographing the same thing as they do, you'll get something unique. When everyone is shooting frame after frame in one direction, turn the opposite way.

We sat in a small, badly lit concrete house in Dharamsala listening to Kaavya teach us how to make momo, the Nepalese version of dumplings. We spent hours stuffing tiny portions of meat and vegetables into small pouches of dough and steaming them in bamboo baskets.

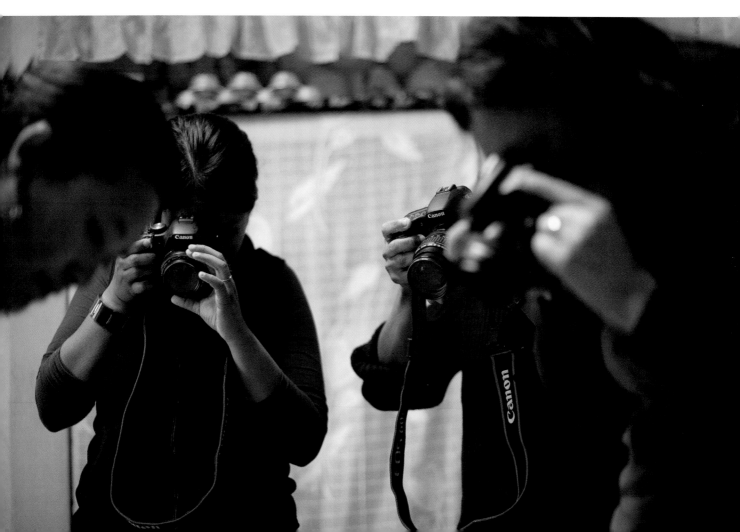

39

ADDING PERSPECTIVE

The moment you press the button on your camera, you are making a two-dimensional copy of the three-dimensional world. You are flattening everything. But our eyes are used to seeing things in 3D, so we need to enhance that in photographs to give them more interest and prevent them from becoming boring. One way to give the appearance of depth is to use a trick from the old masters. Let lines flow from the front of the picture and fade out far into the background.

Dave was eating a fish burger and watching his friends ride the waves at Bathsheba, or Soup Bowl, on the east coast of Barbados. The salt from the ocean found its way through the air to my skin and made it sticky. Dave introduced me to the rules of catching a wave. There is a specific system for waiting in line. You always wait for your turn and never cut in line. If you do, there might be fists flying, he told me without taking his eyes from the sea.

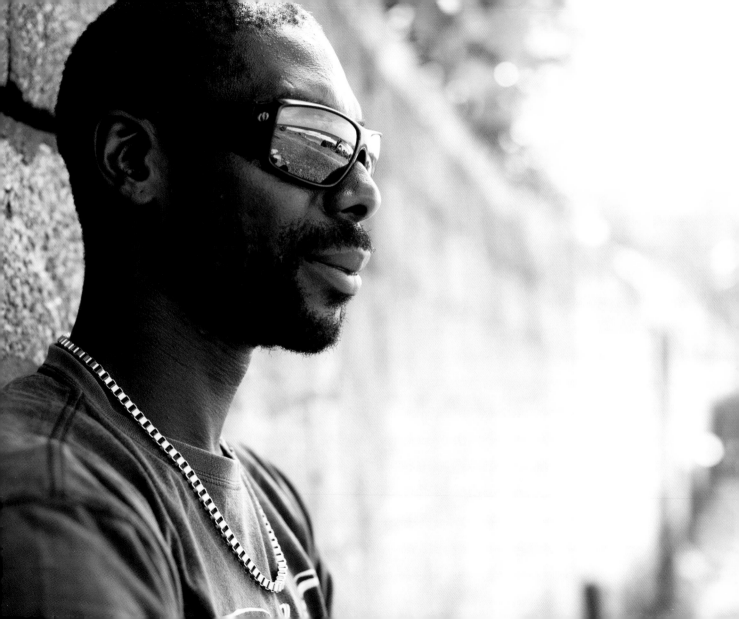

40

BE YOUR OWN VAN GOGH

There are a million things to photograph, that's for sure. As a photographer you're responsible for showing the viewer what's important and what's not. Think of your viewfinder as a canvas within a frame. Compose and crop the reality inside the camera, before you click the shutter and freeze it forever. Make a habit of pausing for a few seconds before you expose the sensor.

One of the city's iconic Yank Tanks stood parked on a busy street in Old Havana. I had only arrived the day before and my body – used to the Swedish winter – had not yet acclimatized to the temperature. I was downing a bottle of water when I noticed the small, tattered Cuban flag on the car. I circled around for a while, trying to find the best background. I probably looked like some kind of foreign car thief, but that's a small price to pay for a good picture.

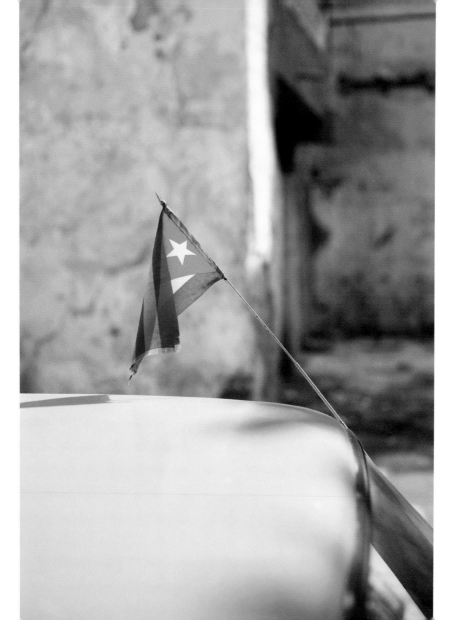

EXERCISE 2: UNHAPPY THOUGHTS?

Even before we can even walk, we are taught to smile whenever a camera appears. A portrait without a smile is a failed portrait, right? Well, I beg to differ. Whenever a person is laughing or smiling in a picture, you will look at that image and think "she is happy". And that's about it. There's not much more to discover; nothing more to reflect on. But when you manage to capture a "neutral" face, you'll soon realize it is anything but neutral. The model's face will reveal every small expression, scar or tension, telling much more about their story than laughter would.

This exercise will help you to:
• Set the mood for creating smile-free portraits
• Understand why a straight face can be more interesting than a smile

 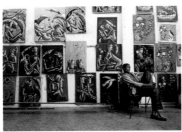 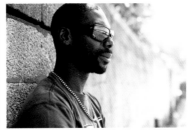

STEP 1

Ask a friend, someone you feel comfortable being around, to be your model for thirty minutes. Find a quiet location – indoors with natural light coming through a window will work just fine. Use a clean background without bright colors. Explain to your friend what your exercise is all about: taking an intimate portrait without any laughter or funny business.

STEP 2

The most important thing about creating a calm, straight-faced portrait is to transmit that same feeling yourself. If you want someone to smile or laugh for the camera, you need to keep your own energy very high. But when trying to capture a face's smallest nuances without any smiles, your body and mind must remain very calm. If you're constantly trying to contain your laughter, your model is likely to get the giggles, too. Be calm, and talk only when necessary in a quiet voice.

STEP 3

When you have decided on a time limit, you will probably notice that you aren't feeling as stressed yourself. You both know that this is an exercise and you both know that you'll be doing it for the next thirty minutes. Don't be afraid to look at your model before you lift your camera to check what the light looks like. After every picture, look at the screen and see what you could do better on the next shot.

For most of you, this will be a completely new way to take pictures of people. It could be very hard to lower your own energy enough for it to reflect on the behavior of the person you're portraying. Take a deep breath and relax – it's what you need to do to get the shot.

41

OUT OF FOCUS

Placing your main subject out of focus will have an interesting effect on the viewer. If the subject is a face, human or not, it will instantly grab the viewer's attention. But because it is unfocused, the eye will register the face and then keep looking to find what is in focus in the image. By putting the focus on the second thing you want viewers to see, you can steer their eyes around the picture.

On a beach in Unawatuna, Sri Lanka, my four-legged friend and I watched the last tourists leave for dinner at one of the restaurants further up the beach. I was waiting for the light to change; he was mainly looking for something edible. We met every night at the same spot. He stayed in my mind for a very long time after that trip.

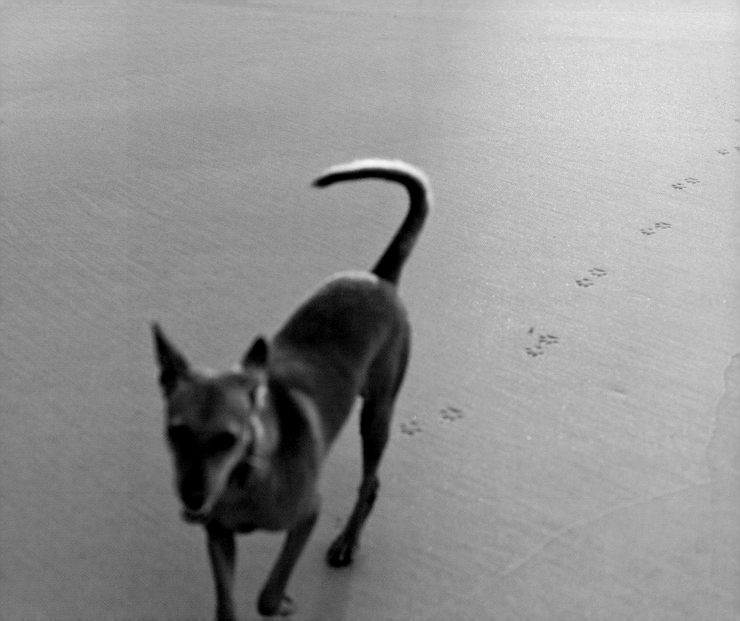

42

PACK IT TIGHT!

Don't be afraid to fill the frame. Don't leave any empty space between your subject and the edges of the picture. Doing that is especially powerful when it comes to pictures of people; faces are interesting enough on their own and don't need much background. You can create more impact by cutting out everything else that might distract the viewer.

"Otra vez! Otra vez!" These three kids, playing outside a small car repair shop, kept me and my camera busy for a long time. They alternated between standing side by side on the street, posing, and hanging all over me and the screen to check out the results. Two of their fathers stood on the other side of the street, laughing.

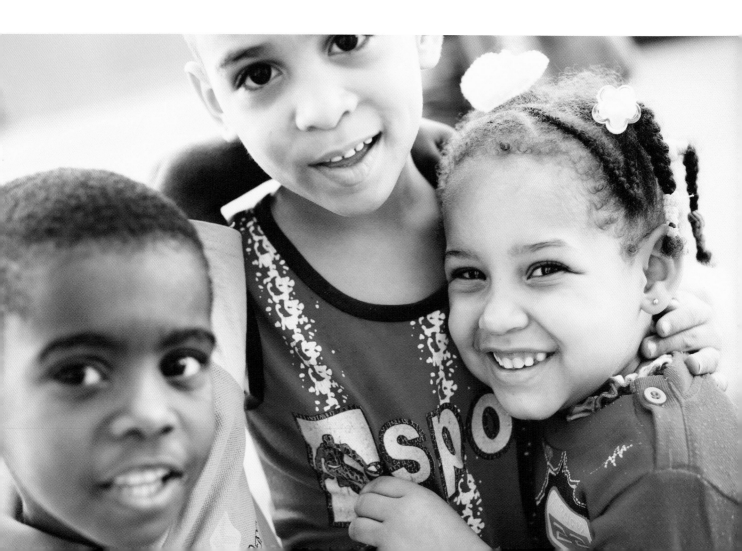

43

BEFORE & AFTER

Have you ever had the feeling that as soon as people hear the click of your camera, they will turn around to see what it was? In those situations you really need to think before you click, because you'll only get one chance. Adjust the settings on your camera and decide in advance what the composition will be. You'll fail plenty of times in the beginning, but little by little you'll learn which settings you need to get the results you want.

This boy sat at the end of the hallway-sized apartment on the stairs leading to the small upper floor. Between him and the flickering TV, his eight bare-chested friends sat totally focused on the soccer game playing on the screen. Every time one of the teams approached the goal, the TV seemed to blackout and everyone jumped up, roaring. The owner of the apartment sold genuine Cuban cigars through his window.

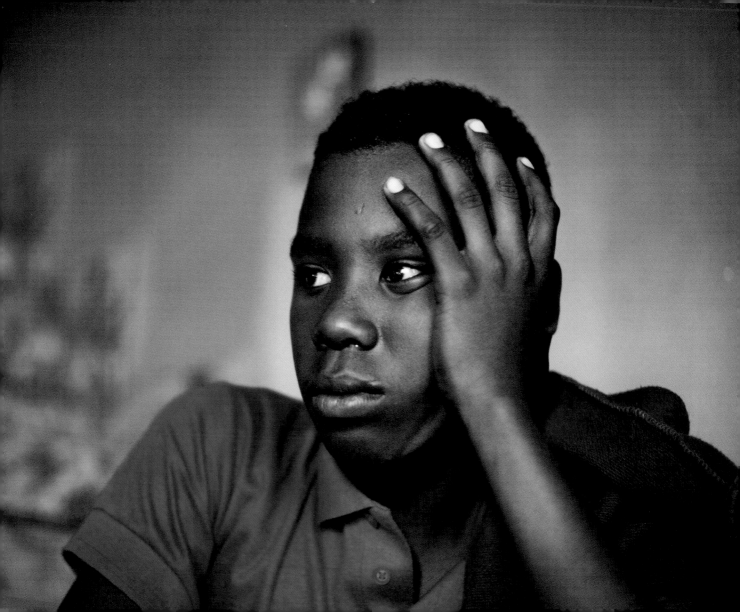

44

IS THERE SOMETHING BETWEEN US?

As I've already mentioned, there are three main layers in each picture: the foreground, subject and background. It's hard not to have a background. It's usually just there, without you putting too much thought into it. But the foreground is sometimes forgotten, even though it's one of the most efficient ways to add depth to a picture. There's a running joke among journalists about how to make boring picture better - just put something in the foreground. It's funny because it's true.

I was able to hide behind a thin wooden wall while the woman haggled with the vendor over a couple of deep fried pastries. The discussion, all in Hindi, escalated until they both burst into laughter. I watched the scene unfold for almost ten minutes; no one seemed to notice me.

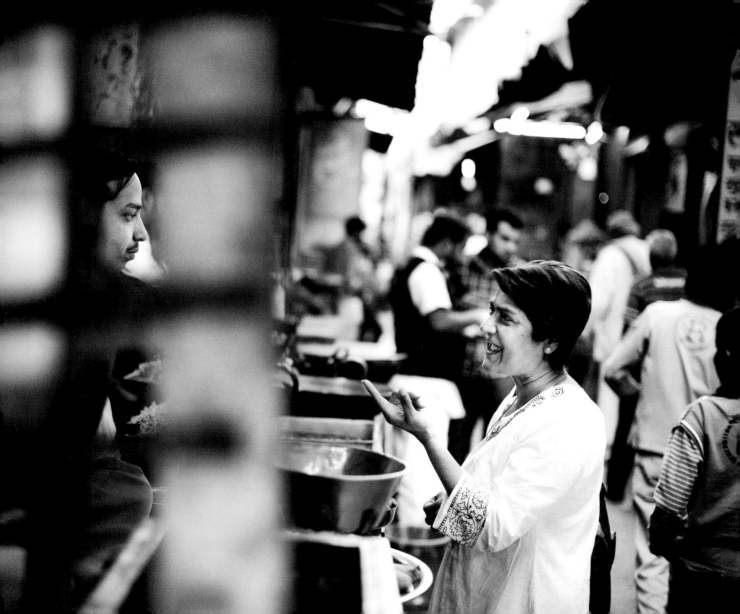

45

SHOW ME WHAT YOU'VE GOT

You might take the best travel pictures in the world. But if no one sees them, what good are they?

Show your pictures as often as you can. And not just by posting them on your blog, Facebook or Flickr. Make prints, frame them and organize an exhibition. It doesn't have to be at a big gallery - a local café is just as good. Or pull out the projector and invite your friends over for a night of food and photos. You'll get other people's opinions and completely new insights into your own photography. Display your images in the real world, not just on a screen!

Sri Lanka was once part of the British Empire and that heritage is still visible in many of the buildings on the island. Beside colonial architecture, you'll also find cricket, and of course, tea. In this hotel in Nuwara Eliya you could get a pint of beer or afternoon tea and play a game of billiards with one of the witty bartenders.

46

I LIKE TO MOVE IT, MOVE IT

Your first composition is seldom your best one – that's one of the rules I live by. After you've captured the first shot, move around a little. Try it from a different angle, crouch down, zoom in. Don't be satisfied until you've tried every possible option. You can decide which one is the best when you get home.

During a short stop with a bus somewhere in southern Thailand, a man stood under the shade of a tree selling coconuts. The sun was directly above our heads and four young girls walked by holding umbrellas to protect themselves from the hot glare. I started taking pictures from inside the bus, and then I slowly zoomed in on the coconut salesman. After a while I was so close that the only thing captured in my lens was his merchandise.

47

HERE IS THE NEW THERE

It's usually easier to take good pictures in exotic places than in your hometown, right? With so many new impressions and experiences, it isn't hard to find great subjects to shoot. But if someone traveled to your hometown, they would also find it exotic and interesting. When we live in one place for a long time, we stop paying attention. Break that pattern. Walk around your city and find places where you've never been. You don't have to travel far to travel. If you can create great picture in your own backyard, you can do it anywhere!

I was scouting locations for an upcoming commercial shoot at Ribban in Malmö. Crawling around on the wooden pier, a couple on bikes passed me. I figured that I couldn't make myself look any weirder, so I started taking their picture. The chance passing of the two cyclists added scale and interest to the image.

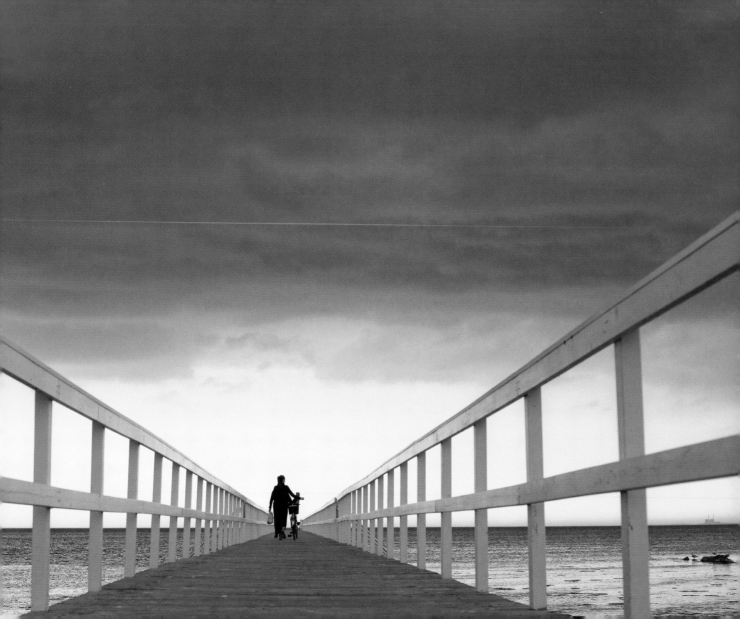

48

READY, AIM, FIRE!

Sometimes, even if you don't need to, shoot from the hip. Don't look in the viewfinder, just point and shoot. Using this technique will surely generate lots of useless material. But it will prevent you from thinking too much and that's great! Sometimes you'll hit gold. Pictures shot from the hip usually feel very spontaneous. Because they are.

I was just getting the hang of shifting gears with my furry transportation when we arrived at the beach. We were completely alone. White, foamy waves rolled onto the sand. Our guide turned around to face me. "Keep the reins tight on that one," he said while nodding in the direction of my Barbadian horse. "When he gets too warm, he likes to lie down and roll." Oh. Thank you. Glad you told me. After that warning, I really didn't want to put my camera up to my face and risk a busted head. I shot most of the pictures LOMO-style (don't think, just shoot!) from that moment on.

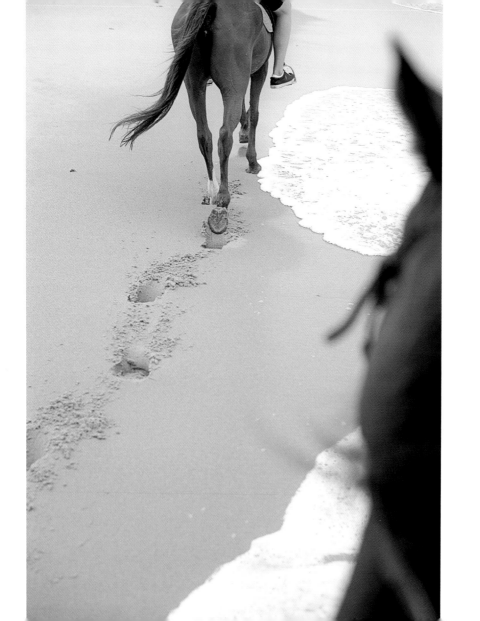

49

PRIDE AND PREJUDICE

Photography is not just about taking pictures - it's about having experiences. To do that, you need to open your mind to everything that is new. Learn to create your own opinions about people or places. We easily develop preconceived notions about places we've never been and know very little about. Try to arrive at every new location with an open mind so that you can create a completely fresh impression.

What's the first thing that comes to mind when I say "Albania"? Nine times out of ten, it's not something positive. It was the same for me until I went there myself. When I arrived, I was welcomed like I had never been before. Everyone was unbelievably helpful. I was invited over, fed, shown around and given a place to sleep. I spent the first few days feeling ashamed of my preconceptions.

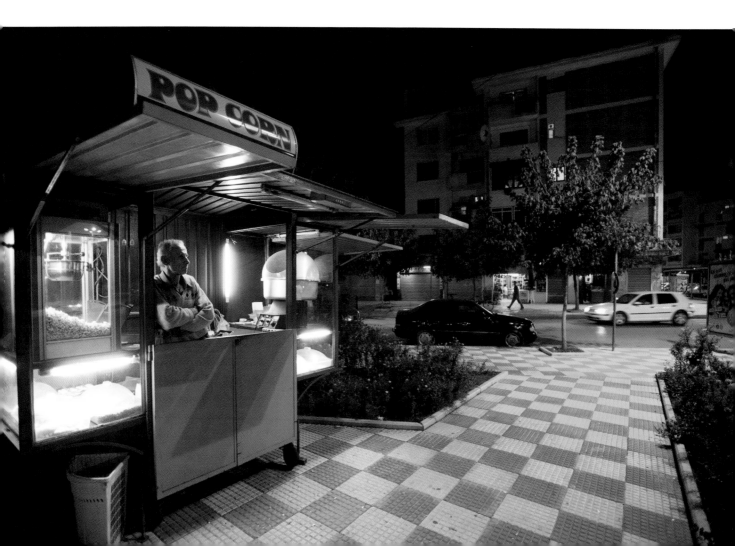

50

SYMBOLIC VALUE

How can you create a sense of place by using symbols? I'm not talking about literal symbols, but rather the details that tell the most about a certain place. It could be a special knife in a fisherman's boat, a broken surfboard in a shop or a bloodstained rag in a hospital. Even if you don't show the big picture, what is the one thing that will tell the viewer exactly where you are?

The broom and leaves in the photograph were laying on the floor of a tea factory in Sri Lanka. After being picked in the early morning by workers with quick hands and baskets on their backs, the leaves were transported to the factories where they were oxidized and ground. The tea was then packaged in huge bales and sold to the highest-bidding tea companies worldwide.

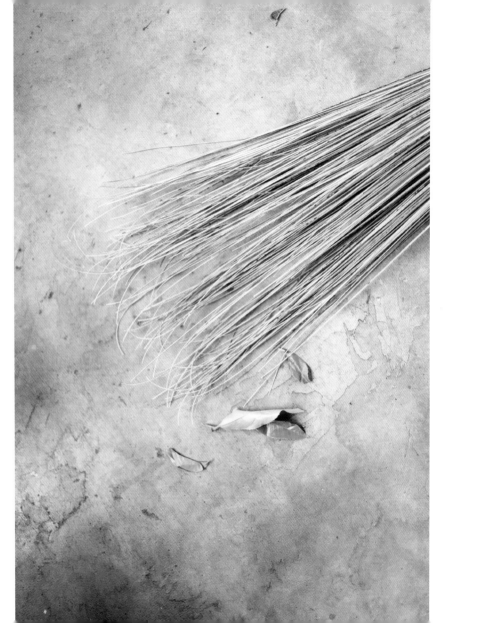

51

PANORAMIC MOTION

Pictures are a moment frozen in time. Because everything in an image is perfectly still, you need to get inventive to show movement. If you set your camera to continuous shooting mode, it will keep taking pictures until you release the button. To follow a moving object in your viewfinder, you need to keep the object in the exact same position within the frame at all times. Then slowly press down the shutter release. If you do it right, by panning your camera you'll get a blurry background and a razor-sharp object.

While a ride in a regular American car costs around 25 cents, a spin in one of the fancy tourist versions could set you back at least a hundred bucks an hour. You'll usually find them near the Capitolio in Old Havana. Or more accurately, they will find you. The most commonly heard phrase in that neighborhood is probably "Taxi, sir? Taxi?"

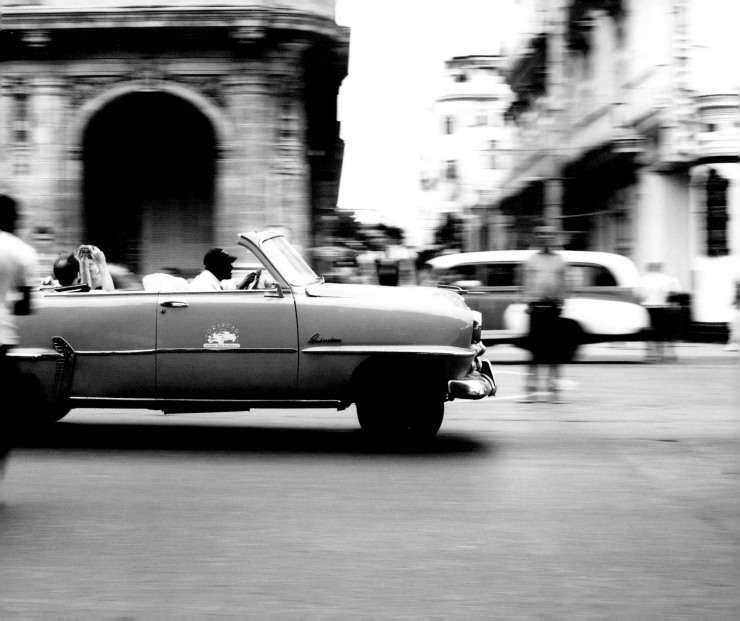

52

TRAVEL LIGHT

Do you know how it feels when it's really hot, you've been sweating on a bus for five hours and now you have to drag your heavy bags through the entire city to find your hotel? I know the feeling well, and that's why I now pack as little as possible. That goes for my camera equipment too! I travel with a maximum of three small prime lenses; they cover all my needs. No flash, no tripods, no nothing. Carrying fewer things will make you more mobile, more flexible and less tired. All very good traits for a traveling photographer.

I became close friends with Anna and Ranjan during my week in Pushkar, India. We spent the days walking around the city. At night, we sat on the roof of our hotel eating chicken and drinking beer. Since both meat and alcohol are forbidden in the holy town, we had to smuggle it past the city limits on a Vespa. But forbidden fruit always tastes better. On one of those nights I took this picture with my super-light 50mm lens, a piece of equipment I use for at least eight out of ten pictures.

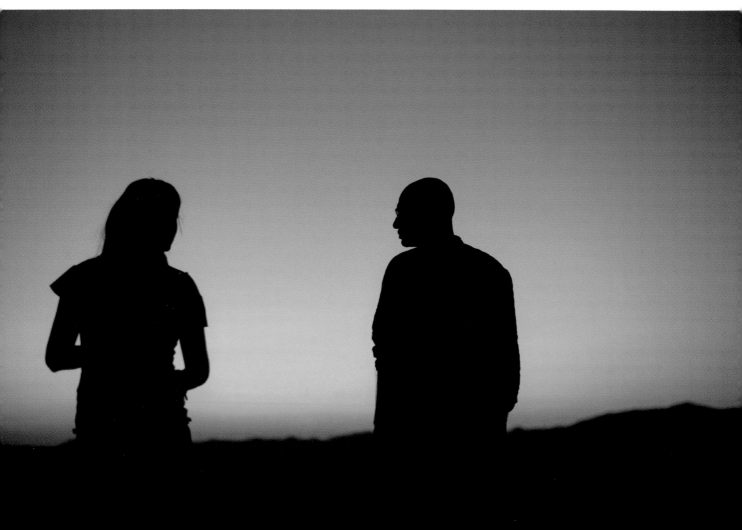

53

LET GO

Taking pictures is a hard job. Maybe not always physically hard, but your brain is constantly working. Allow yourself to refrain from finding the next great picture and just relax. Constantly looking for pictures might even make you a bit blind, and then you will actually MISS the shot. More importantly, letting your brain rest for a while and just socializing could nurture your artsy side a lot.

The day after the wedding of two friends from New York, we set sail on a catamaran. We spent hours sailing along the shore of San Juan, Puerto Rico. Relatives had come from all over the US to attend the wedding and during the boat trip I got to know most of them. I love the story that unfolds when you first read the "no smoking" sign and then decide to see what happens if you don't follow its advice. This was the only picture I took on the entire trip. The rest of my time was spent chatting with my fellow shipmates.

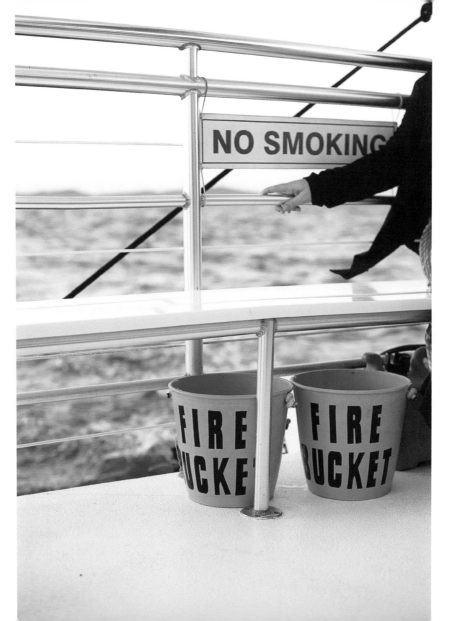

54

GO DEEP

You're standing on top of a mountain looking down and you feel like you're king of the world. The scene you are looking at is breathtaking, so you snap some pictures. And when you get home? "Well, I guess you had to be there," you think with disappointment. When it comes to landscapes, the need to create depth is more important than ever.

I drove a convertible down Highway 1, one of the most iconic road trips in the USA. Between fashionable LA and laid-back San Francisco, the road was bordered by the enormous blue ocean on one side and hot, dusty land on the other. It might be cliché, but there are few places that will make you feel as free as Highway 1.

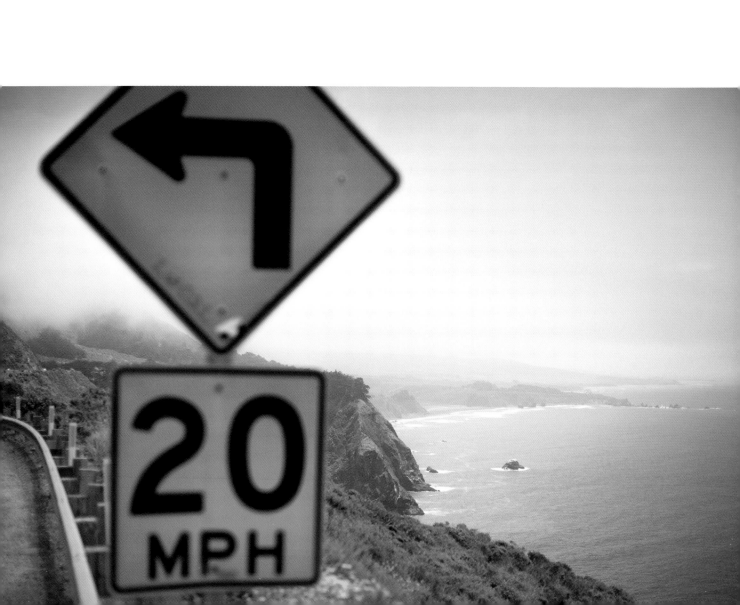

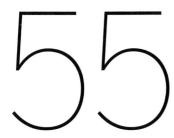

FROM THE OTHER SIDE

If you haven't done so already, it's time to forget the old always-keep-the-sun-at-your-back-when-you-shoot rule that your dad taught you. It's a bit tricky at first, but when you get the hang of it, backlighting is your best friend. I love the milky light created by sunbeams hitting the lens. Let sunlight hit the lens straight on or at an angle. The best time to take advantage of the backlight is one or two hours after sunrise or before sunset.

Before the beach was filled with tourists, beach towels and restaurant tables, a few fishermen tried their luck and threw small nets out into the water. While everyone else was sleeping, their eyes were sharp and alert, looking for a possible catch. On the beach a middle-aged man gazed at his friend with the net. The Thai fisherman was standing between me and the sun.

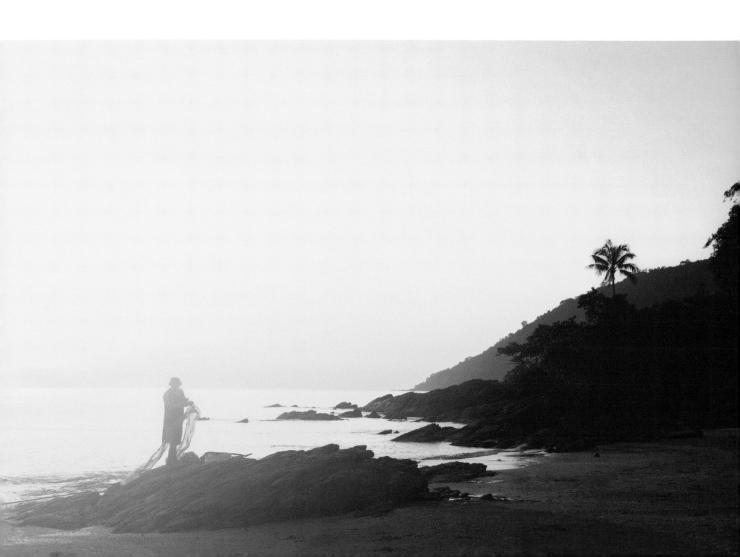

56

THE SKY'S THE LIMIT

Use the sky to give your subject a clean background. If you feel that the picture is too cluttered or the subject isn't popping out as clearly as you'd like, try crouching down to frame it against the sky. Try different angles to figure out what works in different situations.

When I arrived, I was lucky the people on Venice Beach were heading home. The few that were left probably started looking for snipers when I literally threw myself to the ground. I was slowly walking towards the seagull when I saw that he was preparing for lift off. I think I actually managed to look through the viewfinder and set the focus on my way down. The seagull rolled his eyes as he soared away from me.

TINT AND TEMPERATURE

If you are shooting in RAW instead of JPEG (which you should be) you've probably noticed the tint and temperature settings. These help you to get the white balance right – meaning that the white areas in your pictures will actually look white. Generally, you're using tint and temperature to get a neutral result. But if you push them too far in one direction or the other you'll get a color cast that can create an interesting mood.

At that very moment, Brooklyn felt like a kettle ready to boil. Small groups of people gathered to form larger crowds on the sidewalk, with everyone dressed for a night out. On the balconies friends were getting started with cold drinks, singing and shouting throughout the neighborhood. Soon many of them were heading over a bridge to Manhattan. Many wouldn't return until sunrise.

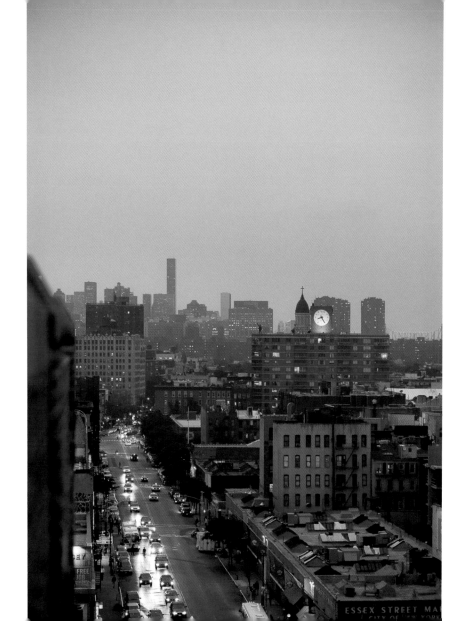

58

THROUGH THE BATHROOM WINDOW

I have a peculiar work-related habit. Whenever I arrive in a new place, a new room, I always check where the light comes from. Where are the windows and how does the light fall? It comes in handy later when I see a good photo opportunity. Without a doubt, the best indoor light source is a large window.

Brian Talma's kids were running between our legs, looking like miniature versions of himself. Dark brown skin, sun-bleached hair and the same gigantic smile as their father. At first I thought the former professional surfer was calling them cute nicknames. But I later realized that their actual names were Sunshine and Princess. Just to the left of where I took the picture, a huge window let the daylight in.

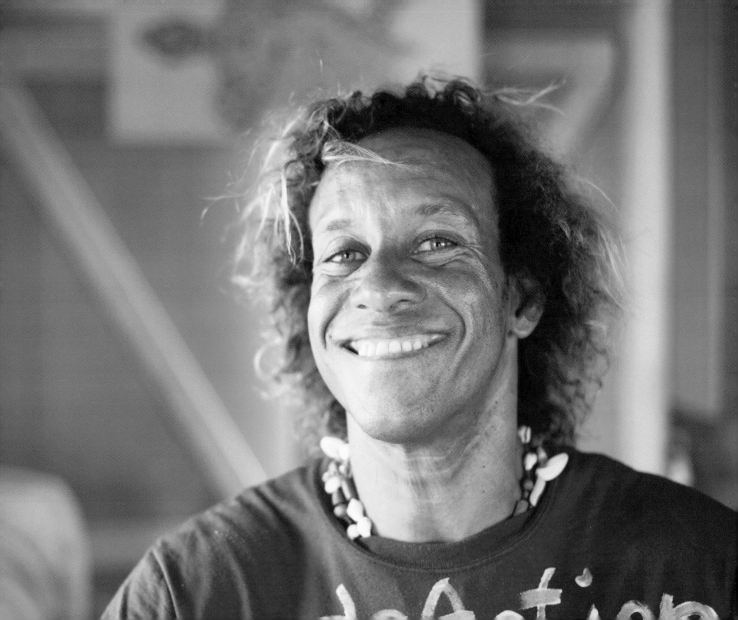

59

IT BELONGS TO YOU

You are what you own - at least on a superficial level. Use that when taking pictures. What can you find on or around your model that will tell his or her story? A person's possessions reflect who they are in many ways. Use that when you are portraying someone.

The taxis in Havana are home to of hundreds of drivers during their long working hours. And they are decorated as such. Stepping into one of these cars is like visiting a tiny apartment. Belongings are scattered everywhere and you can learn a lot about your driver.

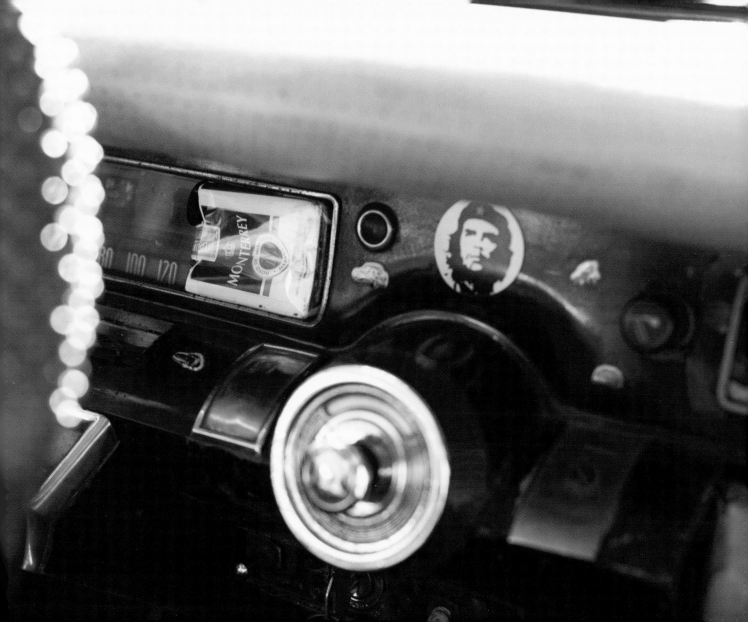

60

THE COLORS OF LIGHT

Our eyes are very good at adjusting to light. When you are just looking with your eyes, you probably won't see the different colors produced by different light sources. But the camera will. In a picture, incandescent bulbs give off a yellowish light, fluorescent lights look green and daylight is tinted blue. These different lighting scenarios provide some pretty interesting effects. When the daylight is weaker, these effects will be even more pronounced.

If you walk west from the more touristy Old Havana, you'll soon enter Centro Habana. Here you won't find souvenir shops or spotless touring cars. It wasn't even possible to run your own business in Cuba until just a few years ago. Outside one of the paladars (family-owned restaurants) now found throughout Centro Habana, this young man tried to attract occasional customers with dirt-cheap mojitos.

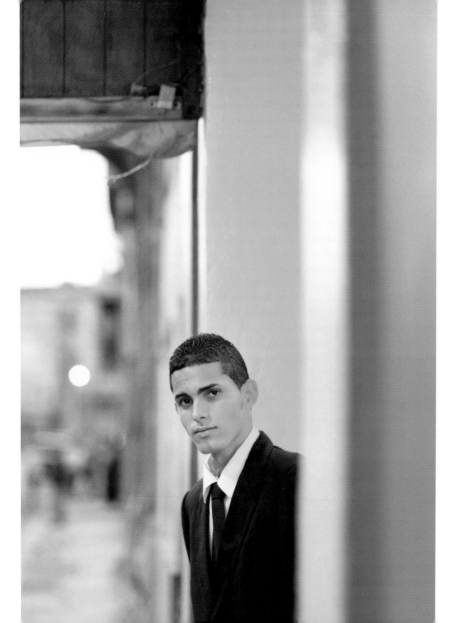

Since the introduction of digital cameras, we have gradually stopped thinking before pressing the shutter. It doesn't cost anything to take another picture, so it's easy to just keep shooting until you get something that looks good. Instead, spend a tiny bit of time thinking through the picture before you click, and take a moment to reflect on the results afterwards. You can actually learn something from every frame.

This exercise will help you develop a skill that many amateur photographers don't have: being able to think. You'll learn to:
- Reflect on your images
- Be able to see a picture before you take it

STEP 1

Spend half an hour brainstorming portrait ideas for a friend that's agreed to model for you. Choose a person who is dramatic or has a vibrant personality. The finished photograph should say something about your subject and should also include at least one prop. Is your friend a surfer? Bring the board. A race car driver? Then include a car. But it doesn't have to reflect the complete truth. Feel free to position the race car driver in his helmet in front of a rusty Lada, or put the surfer on a beach with a tiny paddleboard. Decide on the lighting and background as well as the general feeling or mood. Be sure to write everything down.

STEP 2

Meet your model at the place you've selected. Your mission is to build the image before you press the shutter. You need to get everything right. Finalize the pose, lighting, background, composition and everything else BEFORE you take the picture. Because you only have ONE shot. When you think that everything is in place, raise your camera to your eye and look. The viewfinder will show you almost the exact result. If you're not satisfied, try to figure out what you could do to make it better. After you've gone through this process a few times, you're ready to take your picture.

STEP 3

Afterwards, spend a while thinking about how the result compares to your original idea. If it's not what you were hoping for, what went wrong? Were you stressed? Is it the composition that you don't like? If you're dissatisfied with the result, the first thing you need to understand is what it is that you don't like. Once you know that, it's very easy to know what to change. Feel free to start over with a new idea and one more frame.

When you start to reflect on your own photography (as well as the photography of others) you will do something most lesser photographers don't. Believe it or not, it will sky-rocket your development as a photographer.

61

DON'T SAY CHEESE

If you look at portraits taken by great travel photographers, you'll see that very few of the people portrayed are smiling. The easy explanation? A smile is just for the camera. If you want to create a documentary-style photograph, you're not supposed to tamper with reality. A smile for the camera is always a fake smile. If you ask your models not to smile, you'll be able to read much more from their faces.

India's many dusty roads lead to countless dusty villages. These small, nearly self-sufficient societies are scattered all over the country. Some of the inhabitants have never traveled further than their fields. The boy in the red sweater came running towards me as I was parking my motorcycle after hours of riding.

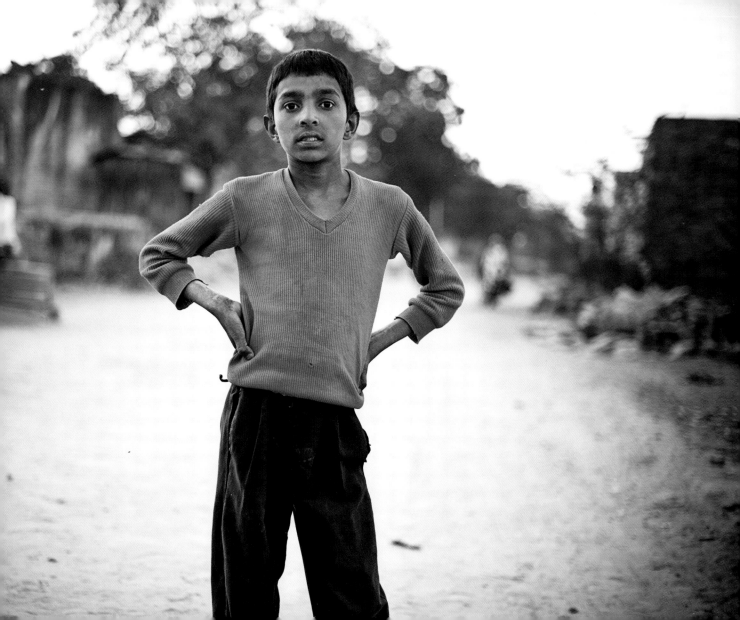

62

THOSE INEVITABLE THIRDS

I can't share one hundred tips on photography without mentioning the Rule of Thirds. Very simply, you can apply this rule by placing your subject a third away from one of the picture's edges. It automatically makes the picture more balanced and pleasing to the eye. Position your subject(s) by imagining that the picture is divided into three equal segments both vertically and horizontally. It's quick fix for better images.

Jonathan (placed about a third from the left side of the frame) is one of the best surfers in Barbados. The minute he finishes his day job at Barry's surf school he and his friends jump into pickup trucks to cross the island for Bathsheba, or Soup Bowl. It's where they find good waves and good friends.

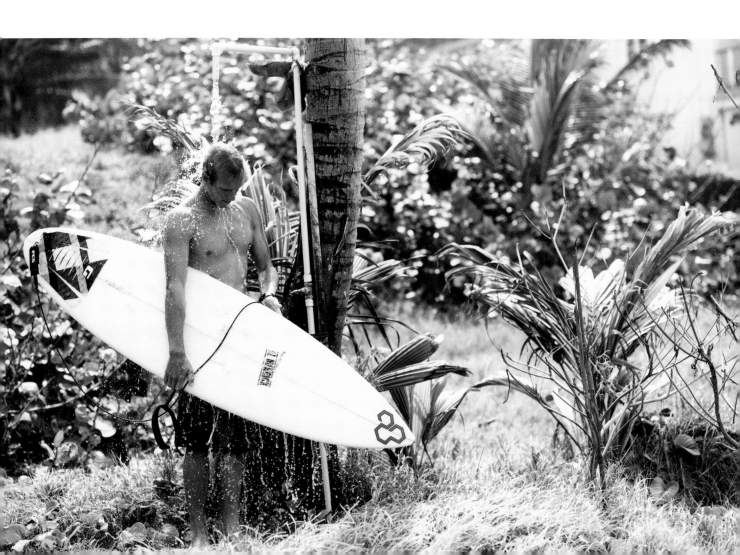

63

IT'S OK, BUT DO IT WELL!

Travel photography is not only about taking pictures of undiscovered places. It's also about taking pictures of well-known things in new and interesting ways. Find a bit of energy and go that extra mile. Instead of just snapping a picture where you're standing, take a minute to look around. What kind of people are there? What are they doing? What do the surroundings look like? Find a new way to portray a well-known subject.

El Capitolio is probably Havana's most photographed building. This is the area where the upscale taxis find wealthy tourists to drive around, and where you hear "Cigar, sir? Cigar?" on every corner. I noticed the motorcycle cops and their boots. They actually have spurs on their heels. I never found out why, but I'm looking into it.

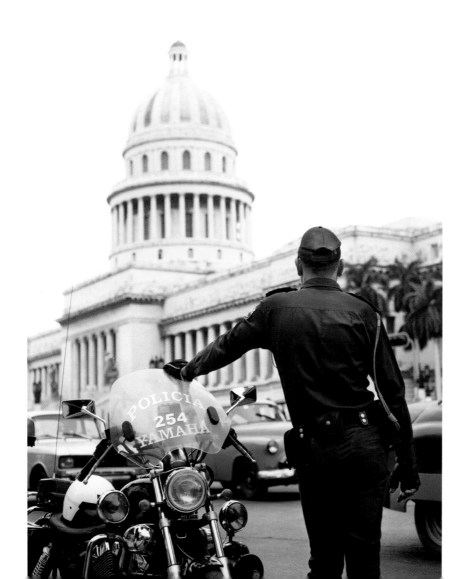

64

SAY WHAT?

Don't dismiss a possible friend just because you can't speak the same language. Humans are experts in communication. We've done it forever. But somewhere down the line we've developed a weird fear of embarrassing ourselves. And that makes us less inclined to communicate with people who don't speak our language. Just take it easy and ask, "Could you say that again, but slower this time?"

When Skhender dropped off me and my two big bags and drove away on his tiny Puch moped, five hours had passed since we'd first met. During that time, he'd shown me his hometown, taught me a lot of Albanian words, bought me the best fish in the country and told me his life story. Even though he was almost 50 years older than me, we had a great time. And the most amazing thing? He didn't speak a word of English and I certainly can't speak any Albanian. Sign language and drawings will take you a long way.

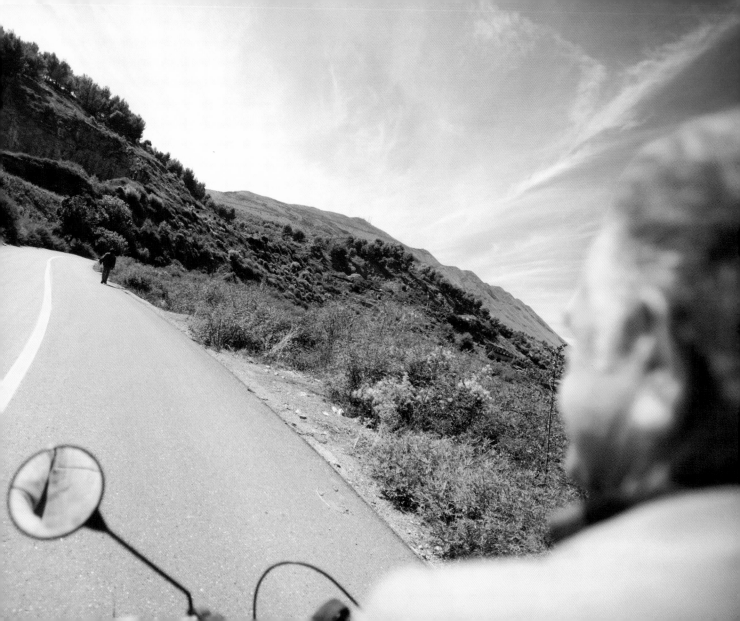

CAN YOU SEE THE PATTERN?

By recognizing all the different patterns around you, you'll be able to create interesting abstract images. It's usually a question of getting close enough. Once you do, try different angles, lenses and compositions.

By the side of the house of a retired professional surfer in Barbados, palm trees shaded the lonely couple lying in their beach chairs. Far out in the ocean, two young boys were practicing their surfing skills. The pro surfer kept an eye on them from his window.

66

LET'S DO SOMETHING ELSE

It is easy to just do whatever crosses your path. But to get great pictures, you'll need to be on the lookout for unusual things. Look for posters advertising weird events, ask locals about what's happening, or simply Google the place you're visiting. What is the strangest thing you could do or see?

I was talking to a man taking pictures of passersby with his gigantic large-format camera when I looked up and saw a huge hot air balloon floating over the city. After a bit of detective work, I found the only company allowed to operate these balloons in India. And one early morning a few days later, I lifted off the ground and hovered above the wakening city.

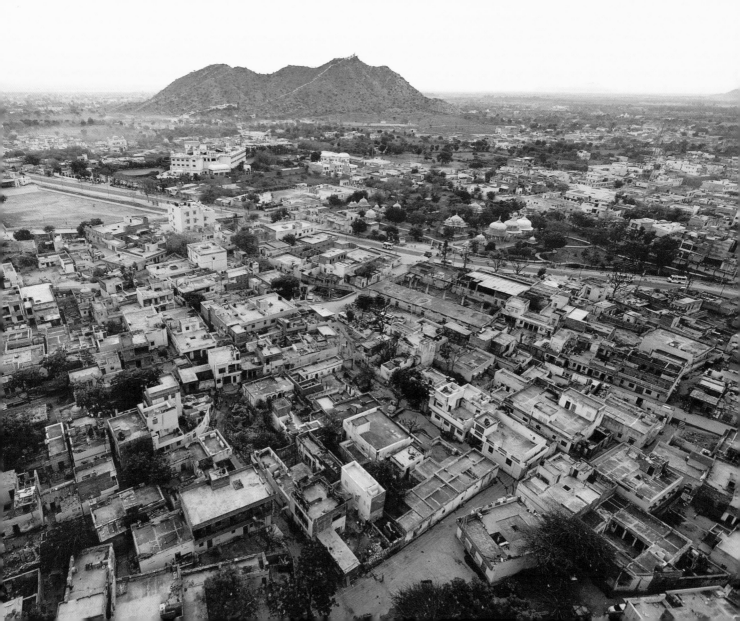

67

RETURN TO SENDER

Did you get amazing pictures somewhere yesterday? Well, go back! Just because you already went somewhere to take pictures doesn't mean you should consider yourself finished with that place! You already feel comfortable there; you know what it looks like. And if you go back, you'll find new people and new light. It can only get better.

I came back to this tiny strip of sand in Colombo, Sri Lanka every night during my stay. I was amazed by the light and the joy on everyone's faces as they played in the hissing waves. A lone soldier was walking back and forth on the stone wall, looking at the different colored fabrics touching the water.

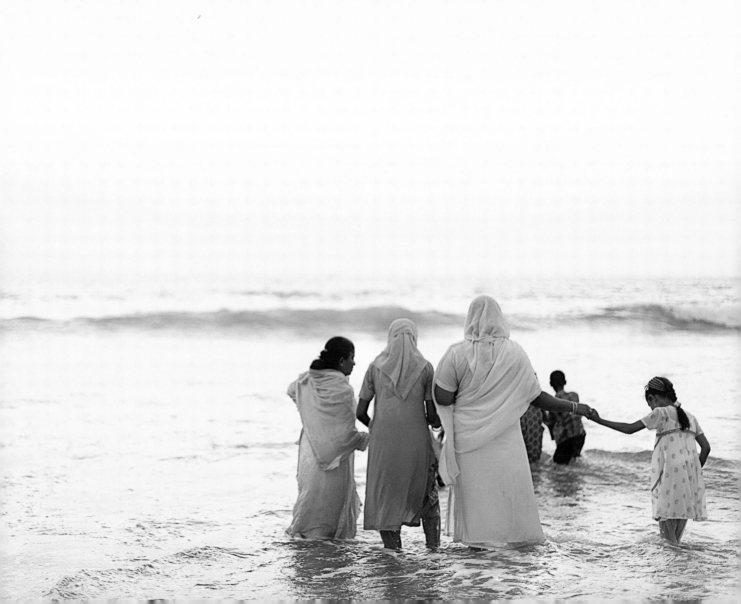

68

HUNGRY?

The way to anyone's heart is through their stomach. The world's cuisines are as diverse as the people cooking them. Food is tricky to photograph. It takes some practice to learn how to make it look appetizing. When you succeed, food photographs can tell you a lot about the places you are visiting.

Right above the stone wall on the beach in Colombo, Sri Lanka, the food vendors seasoned their chicken, fish and popcorn. Parents sat down on the grass to eat while the kids attempted to get their kites up in the air. The smell of grilled meat wafted around the laughing families.

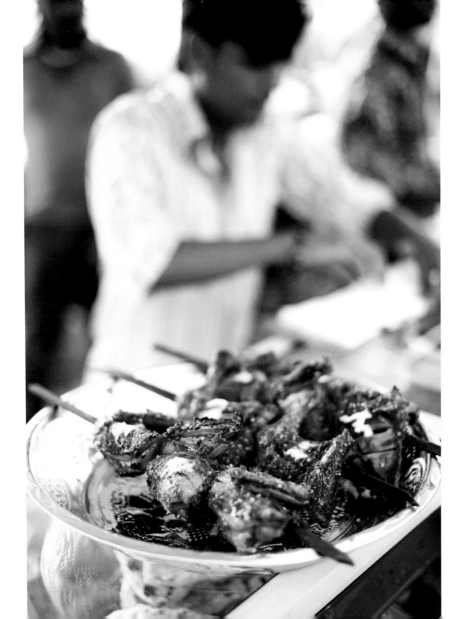

BE RUDE!

As a photographer you HAVE to take pictures. It is your job, even if you're not a professional. And sometimes that means that you won't please everyone. So be rude. Go out there with the attitude that you're going to take that picture, no matter what. When you do see a picture, just take it and deal with the consequences later!

This is the Department of Cultural History in the tiny town of Casablanca, just outside Havana. It consists of one very worn-out room with a similarly worn-out, chain-smoking woman. She told us about the origin of the town's name and why Che Guevara got married there, and showed us pictures of the first inhabitants. But she wouldn't let me take her picture. Fortunately, people aren't very good at judging how much fits in a picture. She thought I was photographing the painting on the wall behind her.

70

NOTHING BEHIND MY BACK

The first step to great travel portraits is putting your subject against an uncluttered background. Don't let anything poke out from your model's head; stay away from poles and twigs. Without a doubt, Steve McCurry is the master of clean backgrounds. After you master the art of cleaning up, you can start adding more objects to tell your story.

Outside the Department of Cultural History in Casablanca, the chef of the village's only restaurant was taking a break as the day took its last breaths. I had actually seen him the day before, but he disappeared before I could ask him for to pose for me. I didn't think twice this time.

71

ALMOST BLACK AND WHITE

Just as you should be careful with how many objects you place inside the frame, you should also keep an eye on colors. Too many colors will make an image feel messy. Try this: Avoid as many colors as possible when taking a picture. If you do it well, the photograph will almost look black and white.

Two cats sat under my table while I ate moussaka on the island of Corfu. I was leaving for Albania the next day and enjoyed the view of freighters slowly passing in the canal between the two countries.

72

BLEND IN

As a westerner you'll most certainly stand out from the crowd in countries like India, Thailand or Sudan. So don't make it even worse. Take a look at the locals. What are they wearing? Try to blend in by wearing the same colors. It's not about trying to disguise yourself, but about putting yourself and those around you at ease.

I ran into this little girl many times during my stay. She walked around the market area in Pushkar, asking tourists for rupees or some food. Sometimes she got a naive westerner to follow her to a shop to buy butter "for her family". The butter was extremely overpriced and as soon as the tourist left, she returned it to the shopkeeper who gave her a bit of money as a reward for her scam.

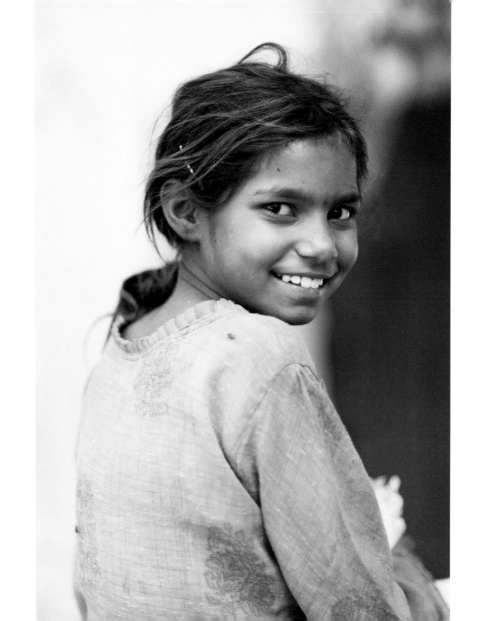

73

THE GOOD, THE BAD AND THE UGLY

It is easy to create nice pictures of beautiful things. But ugly, scary or dirty subjects can be just as interesting. Look at these types of pictures and try to see the beauty in the beast. Only a good photographer can take something hideous and make it beautiful.

Four dogs were running around in the narrow alleyways of Dharamsala, India. Sometimes it looked like they were playing around, other times it turned more serious. Two monks slowed down and looked at the white teeth shining brightly in the dusk before they moved on.

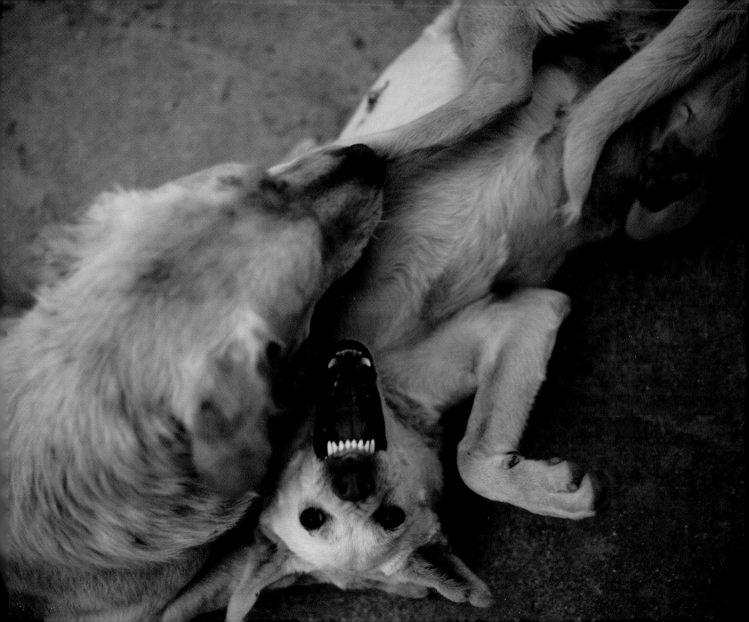

74

DON'T GIVE ALL THE ANSWERS

A great photo doesn't tell the whole story. Instead, it will raise questions and make you think. So don't try to get everything in one picture, and let the viewer complete the story. Think about it like a good movie - one where the ending doesn't tell you everything, but just enough to make you walk around for days, trying to figure it out.

I was back at my favorite art studio in Havana. Johnny wasn't an easy one to get a grip on. On one hand, he acted like a teenager, just in it for the drinks and girls. On the other hand, he was one of the deepest thinkers I've ever met.

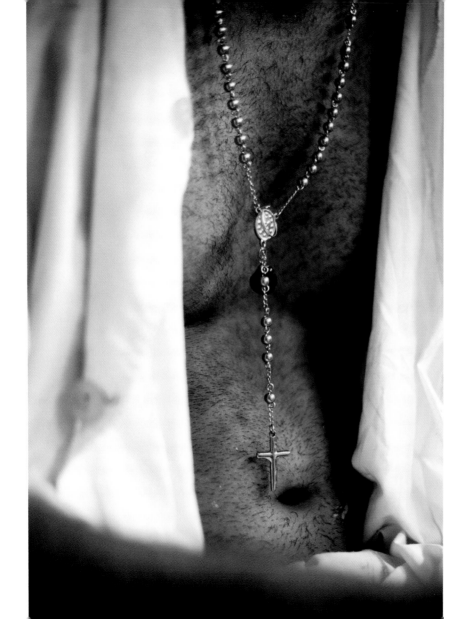

75

SMALL & QUICK

When I do commercial work, I always bring a professional DSLR camera to deliver pictures with enough resolution for large prints. But I also bring a smaller camera to keep around my neck at all times. One of the reasons is so I never miss an opportunity. But the main reason? It'll let me play around more. I can let go of Professional Me and go nuts with composition, angles and light. Sometimes you just need to have fun.

I usually get really tired of the hotel breakfast after a couple days. My small Fuji camera helped me get through a week of badly cooked, rubbery bacon and sugary pastries at a luxurious Barbadian hotel.

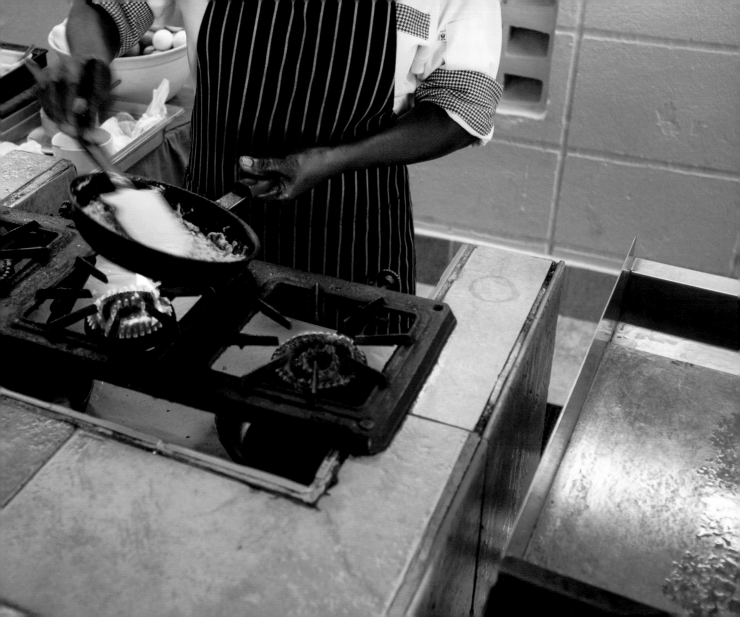

76

CHECKING IN

Just because you're safe in your cozy hotel doesn't mean that you have to stop taking pictures. In fact, it could provide great photo opportunities. People are usually less stressed and often have time to talk and to get their picture taken. You'll also have a lot of options for framing the outside world.

I sat quietly reading a book on the roof of my Indian guesthouse. Monkeys played on the blue roofs around me. Suddenly, something towered at my right. I turned my head to see a huge monkey sitting two feet from me on the wall. He was hissing at me as he bared his teeth. And the clever guy had positioned himself between me and the stick used to scare the monkeys away.

77

DISCONNECTING THE AUTOPILOT

A camera isn't very smart. In many cases it'll give you a decent light measurement. But in some cases (and usually the ones where you REALLY need the picture to be properly lit) the camera will mess it up. This is why you should get comfortable with manual exposure. Play around with it as much as possible to get a grip on it. Because when you're standing in front of a great shot, you won't have much time to think.

This boy came wandering over the dusty road on his way home. If I turned my camera a little to the right, I could see the gigantic peaks of the Himalayas, covered in snow. I knew that the bright sky behind the boy would make it almost impossible to use automatic exposure, so I didn't even try. When you're used to using the manual option, it's almost more convenient.

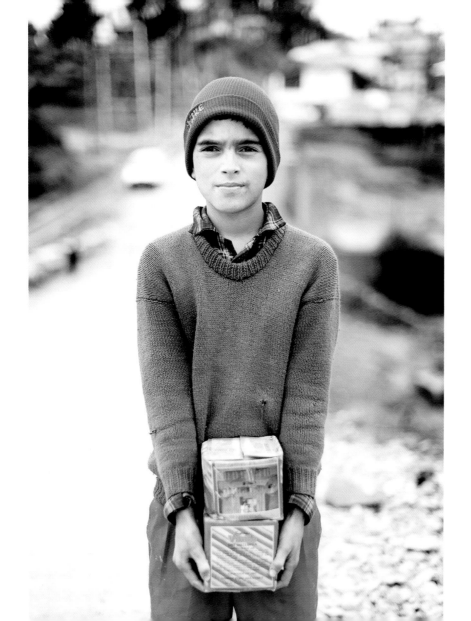

78

PHOTOGRAPHIC AMPUTATION

Whenever you're photographing people, make a conscious decision about whether you really need to show their arms and legs. If there is no real reason for including the limbs, maybe you should leave them out. It's usually best to keep a picture as tight and clean as possible. But when you're sure they're adding something to the whole, keep the hands and feet within the frame.

This picture of a Cuban boy with his football at his feet and his sandals on his hands is one picture where you actually need to see hands and feet to understand the whole story. The boy and his little brother were playing by themselves. Just outside the frame, a group of older kids were engaging in a loud and dusty soccer game.

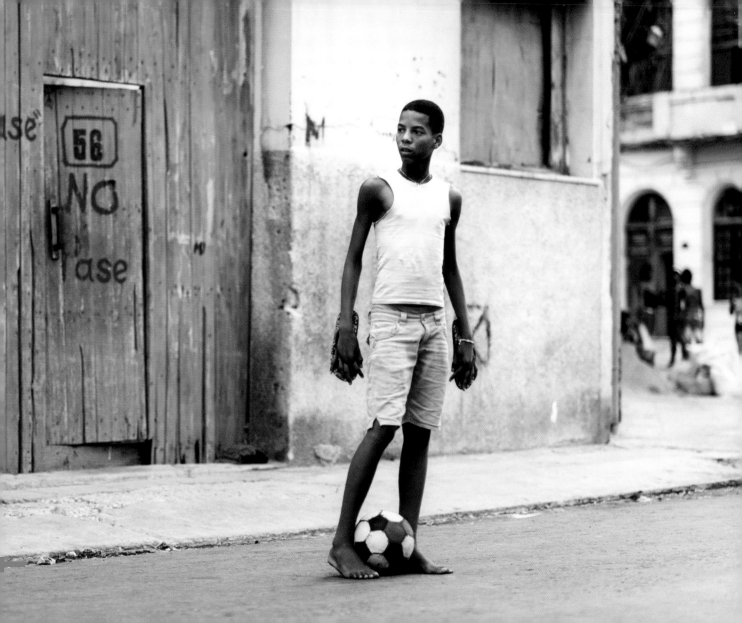

79

IT'S A MATCH!

Are there two elements in a picture that match each other, color-wise? Good! Use that to show a connection or give the picture another dimension.

Standing in front of a tattered wall in Havana, the color of the boy's skin matches the dark pipe behind him almost perfectly. I like it. It kind of ties him to the wall, and makes a connection between the two objects in the picture.

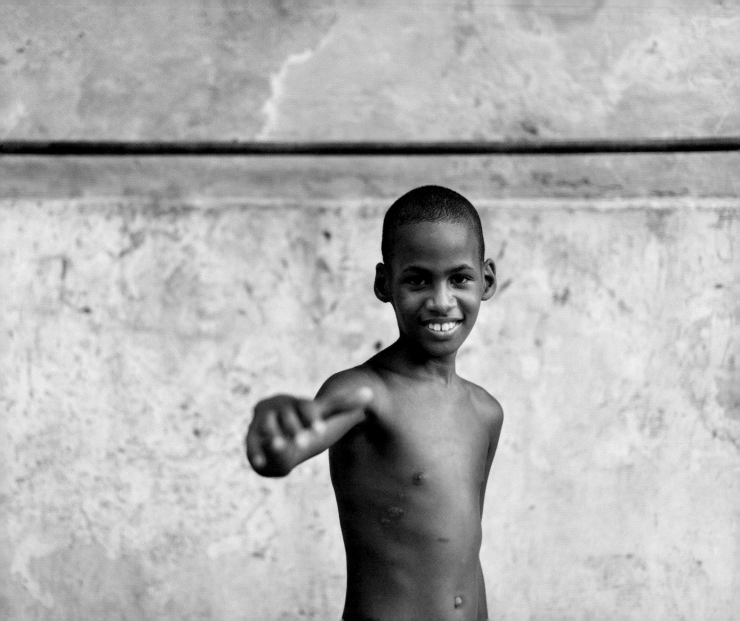

80

BLANK SPACE

Sometimes you should fill the frame. Other times, you´ll compose a better picture if you leave a lot of empty space in the photo. By leaving a large area unfilled, you give the viewer a feeling of freedom.

Venice Beach was booming from the instruments and cheering. No one cared what was going to happen tomorrow or anytime after that. I choose to keep a large portion of the image blank, to let the notes fly towards the open sky. It almost makes you feel as free as the kids.

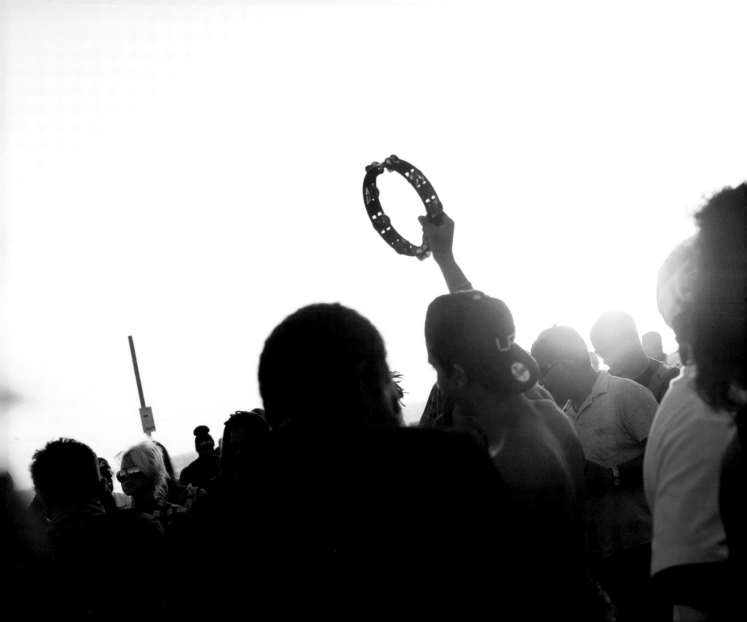

EXERCISE 4: THE BACKGROUND STORY

Photography turns the three-dimensional world into two-dimensional pictures. It flattens space and pushes everything together in a single layer. A messy wall ten yards behind your subject won't be too distracting when you're just looking at it with your eyes, but in a photograph it will appear to be directly behind her. To produce better portraits, it's crucial to start paying attention to the background.

This exercise will kick-start your ability to use backgrounds to take your people pictures to the next level. You'll learn to:

- Improve your ability to let the background interact with your subject
- Find good lighting for your portraits

 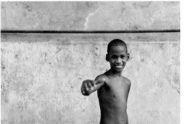

Ask a friend to model for you. Ask him or her to bring a few different outfits, preferably without too many patterns. Plain colors work best. Decide on a time frame, at least 30 minutes.

Your mission as a photographer is to find as many backgrounds as possible that connect with your model in some way. For example, consider similar colors, complementary colors or patterns that could work with your model's outfit.

Once you've positioned your model in the ideal place, pay attention to the light. Is it sufficient? Does it fall nicely on his or her face? If not, you need to reposition your model. After each shot, take a few seconds to look at the results. Reflect and change what needs to be changed.

If you'd like to see how much more interesting a portrait can become just by using the right background, Google "Steve McCurry Afghan Girl". I'm sure you've seen this well-known portrait before, but did you notice the harmony between the background, the girl's eyes and the color of the fabric under her scarf?

81

SHOW SOME EMOTION

If you want to make expressive pictures, find expressive subjects! You can find dancing, sports, demonstrations, performances and plays in almost any city. If the person in front of your lens is already filled with emotion, what could possibly go wrong?

The Ballet Nacional de Cuba is one of the most expressive places I've ever been. Hidden deep in the suburb of Vedado, it is the training ground for hundreds of dancers, including some world-class performers. I made friends with some of the choreographers and returned again and again to take more pictures.

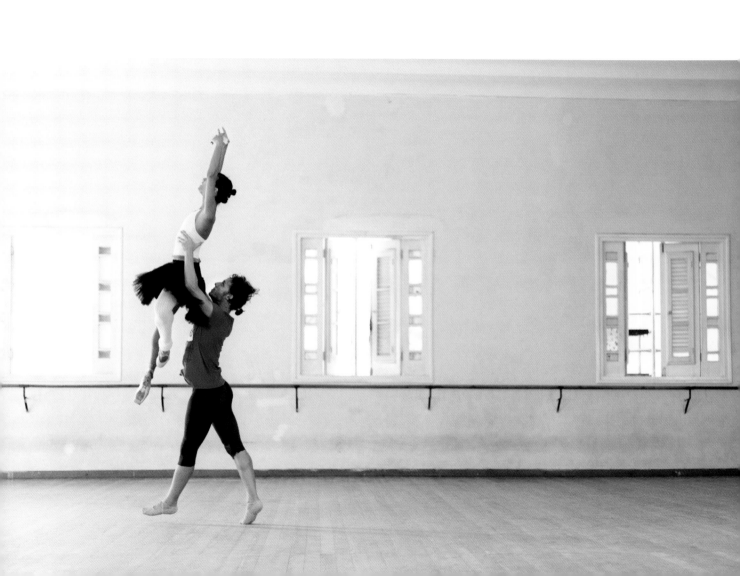

82

THE INTERNATIONAL LANGUAGE

Do you want to know the easiest way to ask someone's permission to take their portrait? Just lift your camera a little and raise your eyebrows. It works in every language, in every country. Train yourself to do it the moment you find an interesting face before you start procrastinating taking the shot. You'll end up with some great pictures.

This woman outside Dharamsala, India had a view of the snow-covered Himalayas behind me. She was sitting in a small wooden hut, serving tea for a couple of cents. The blade in front of her was used for cutting twigs from the nearby bushes.

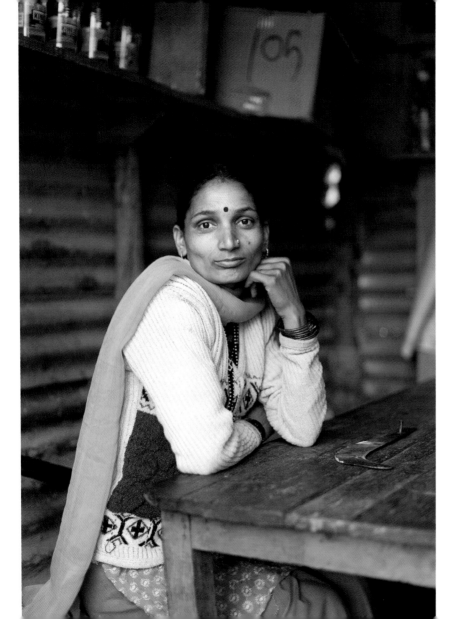

THE OUTSKIRTS

I love the areas just outside a city. While everyone else is trying to cram themselves into the center of town, the areas on the edge of the city limits have their own special character. It is not the city anymore, but it's also not completely outside it. People pass by, but they very seldom stop. Spend some time exploring the outskirts of the city you're in.

Outside Pushkar, India, there are two small mountains. If you get to the top before sunrise you'll have a beautiful view over the city as it awakens. One early morning, I joined two new-found friends from my guesthouse and climbed to the top. For hours we watched the colors change over the city's skyline.

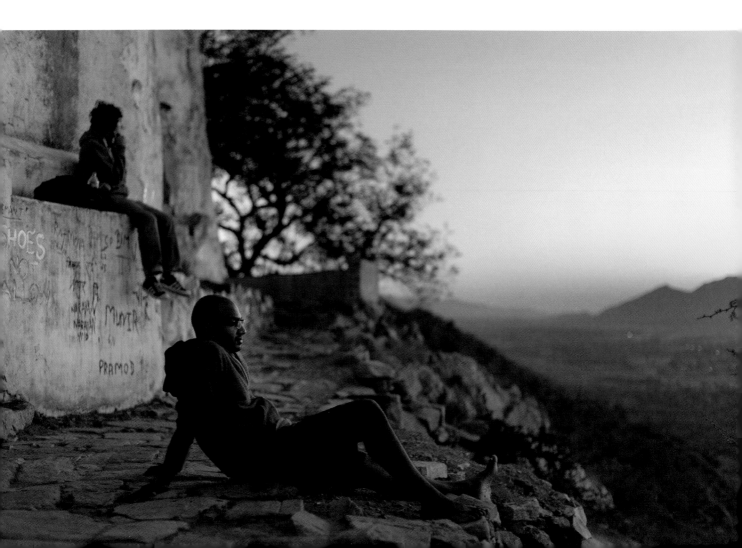

84

SOME EXTRA BLUR, SIR?

Early in their career, almost every photographer will realize that they are taking most of their pictures using the same aperture. You can get stuck in a rut because the blur created by a large aperture often produces nice-looking pictures. But the aperture becomes very useful when you start making active choices about the background. Don't just let everything blur out; make a conscious decision about what to show.

Padminis have long been the preferred vehicle of Mumbai's 200,000 cab drivers. But they are now being threatened by new companies with fleets of shiny, air-conditioned automobiles. The Padmini era is ending, but the cab drivers won't get pushed out without a fight.

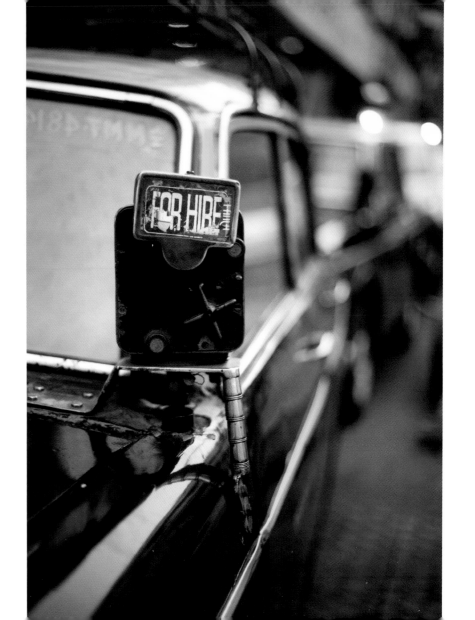

85

WIDER ANGLES

My wide-angle lens doesn't get used too often. But I always carry it with me because when the right moment occurs, I wouldn't want to be without it. The wide angle will help you create a feeling of presence; it will get you closer to your subject. But with this kind of lens, it's more important than ever to get physically close as well. The lens can't do all the work for you!

During my trips to Havana I couldn't get enough of riding in the old Yank Tanks. They were like homes to the drivers for ten hours a day. Friends, parents and girlfriends popped in, chatted for a while and then left a few minutes later. They seemed to know everyone. I was on my way home from a late movie when I hailed a cabbie. He was on his way home, too; he had already picked up his girl. I was his last customer of the day.

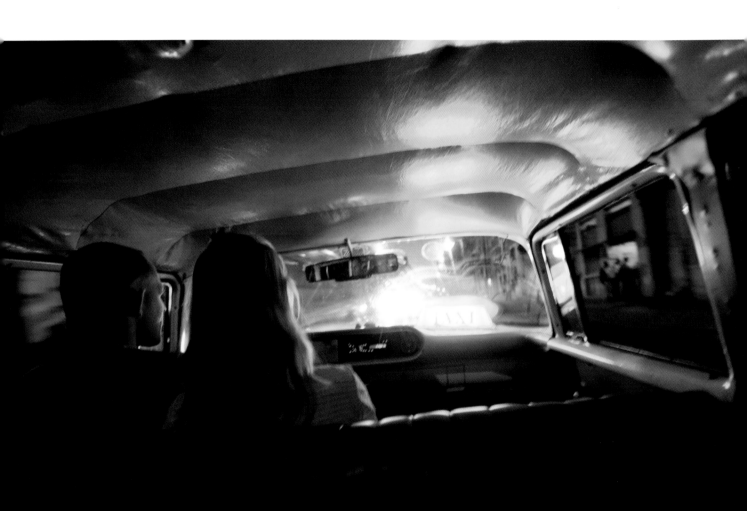

86

LOOK OUT! BEHIND YOU!

Here's a killer technique to use if you don't want your subject to realize that you're taking their picture. If the sound of the shutter gave you away after the first shot, just look really intensely at something behind the person you've just photographed. I mean, REALLY intensely. Pretend what's behind him is the most amazing thing in the entire world and you don't even realize he is there. That's usually enough to put your actual model at ease so you can continue to photograph him.

Zhuque Antiques Market is located in a hangar in Xi'an, one China's best cities for food lovers. You can browse through several hundred small booths filled with different merchandise – some more antique than others. An hour before closing time a half-asleep salesman was waving a fan in front of his face. I needed to time the shot perfectly. If the fan was too far to the left, it would block the light from the booth; too far to the right, it would cover his face. I also had to wait for someone to pass in the background, to add more life to the picture. Every time the tired vendor looked up, I inspected the wall far behind him, with a slightly confused look on my face. Every time, he closed his eyes and ignored me.

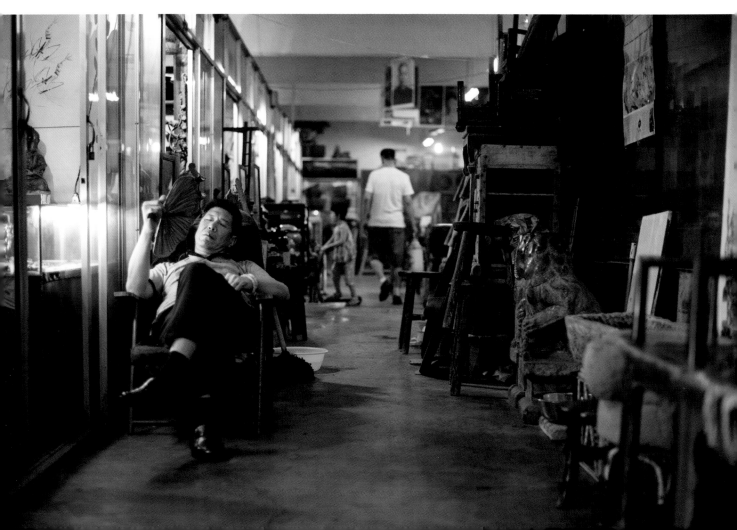

87

YOU'LL NEVER WALK ALONE.

If you're interested in portraits, your greatest mission as a photographer is to connect with people. And trust me, you'll have to step outside your comfort zone quite a few times to build rapport with strangers. One of the best lessons I've learned over the years is that if you want to make new friends, don't bring any with you. If you are constantly walking around with your travel partner, you'll only focus on each other and won't pay as much attention to your surroundings. That'll make you miss a lot of opportunities. When you are going out to shoot, go alone. That way you won't miss any sights, smells, or new acquaintances.

Darren's beard was so neatly trimmed I had to look really closely to make sure it wasn't just drawn on with a black marker. The constantly squinting bartender was pouring drinks at a hotel beside the pebbled beach in Makarska, Croatia. At the same time as we were having a conversation, he managed to effortlessly open beer bottles, shout orders to the kitchen and collect the cushions from the beach chairs when a gentle rain started to fall.

90 DEGREES

If you're hoping for a career as a published photographer, this is a very important tip. Sit down and look through your pictures from the last few months. Chances are, the majority are either in landscape or portrait format. It is easy to get stuck taking most of your pictures in one or the other because it's the format you are most comfortable with. If you submit fifty pictures with the same orientation, you'll probably get an annoyed email from the art director. Push yourself to take every picture in both landscape and portrait format. That way you'll feel more at ease with both!

Nothing said I-don't-give-a-damn like the owner of this tiny blue Mini in Capri Town, Italy. Parked right across two spots, halfway under a plastic "No Parking" streamer, it was clear that this was his space. At first I tried to capture the complete car by shooting in landscape mode. But very often the picture will improve if you cut some parts away. That's why I decided to try another orientation.

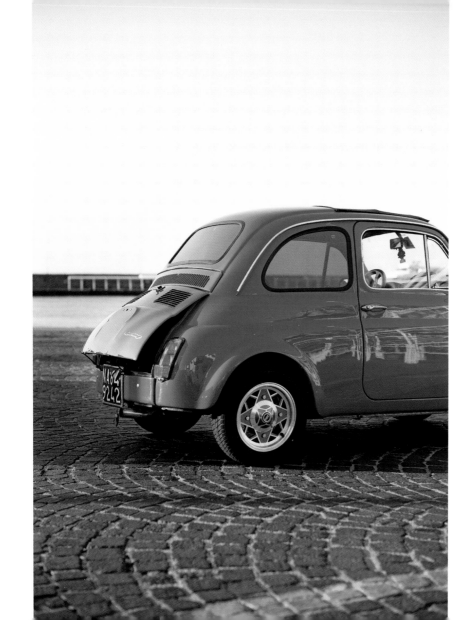

89

DID ANYONE FOLLOW YOU?

When you've found the perfect face to photograph, nothing is more frustrating than the fact that there's no suitable background to shoot him against. Well, if he is moving, that's not an issue! If you manage to tail your subject long enough, he'll most certainly pass several great backgrounds.

This musician was probably on his way to a lunch gig in Havana and the further he walked, the heavier the contrabass seemed. I wanted him to get away from the nicely painted, crack-free part of the neighborhood, and closer to a background that matched his well-worn instrument. After a few blocks he cut into an alley and entered a scene that was much closer to what I had in mind.

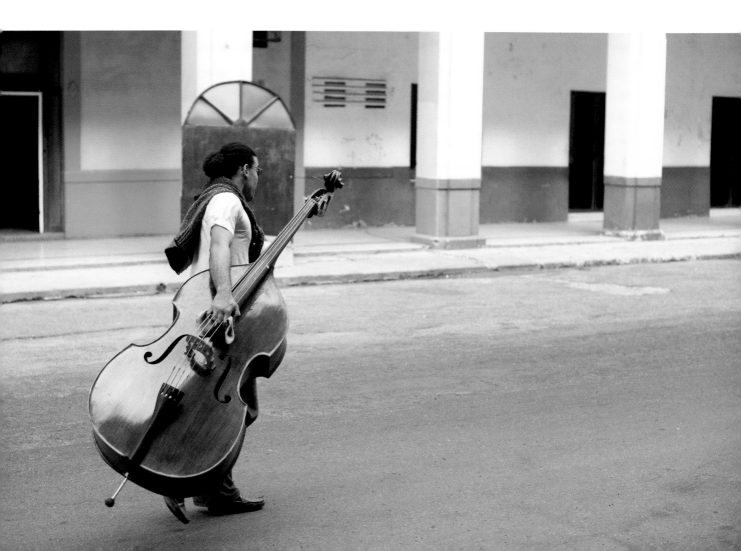

HANDS UP!

A portrait doesn't have to include a face. One of my favorite ways to tell a person's story is to show their hands. Hands can show what a person has touched, felt, caressed or held over the course of their life. When you are talking to a new acquaintance, don't forget to look down at his or her hands – there might be a whole story waiting to be told.

At a not very symmetrical intersection where several dirt roads met, men and women were playing chess while drinking chai. The small market square outlined by the roads was in the center of Pushkar. These hands told the story of someone who had spent years perfecting their craft.

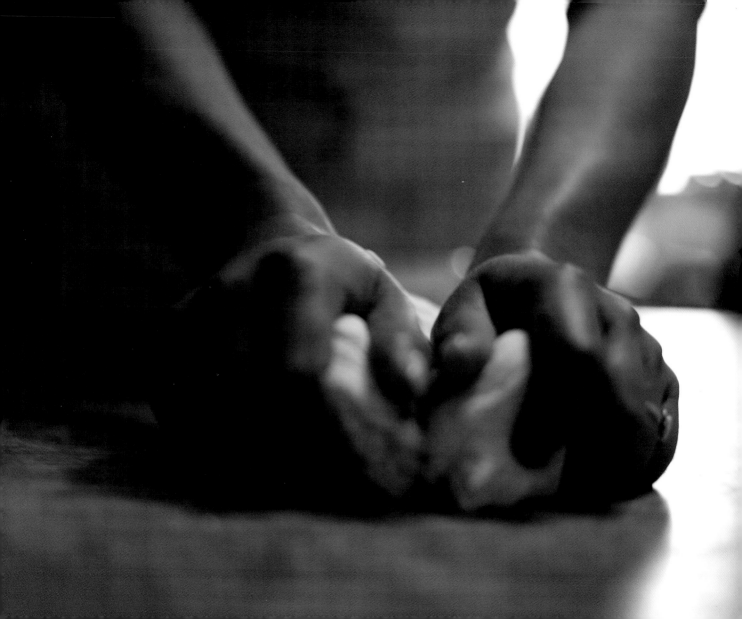

91

DON'T DELETE

The world of photography is not only about knowledge and skill. Even professionals rely on luck to help them create their art. If you've envisioned a specific picture when you lift your camera to your eye, there's a big chance that any other result will feel like a failure. You might want to delete it, right then and there. Don't! I never delete a single picture, not from the camera and not from the computer. Sure, I have to buy an additional hard drive now and then, but sometimes pictures need to mature. Give it time and you might find a masterpiece that you would've trashed a few months ago.

My original intention was to focus on the woman in red, and I got a few shots where the focus is "right". But when I looked through these images from a bustling intersection in Seoul I realized that the picture gained another dimension when the focus was set on the girl in the background. You could still see the woman with the phone, but also the interesting face of the student.

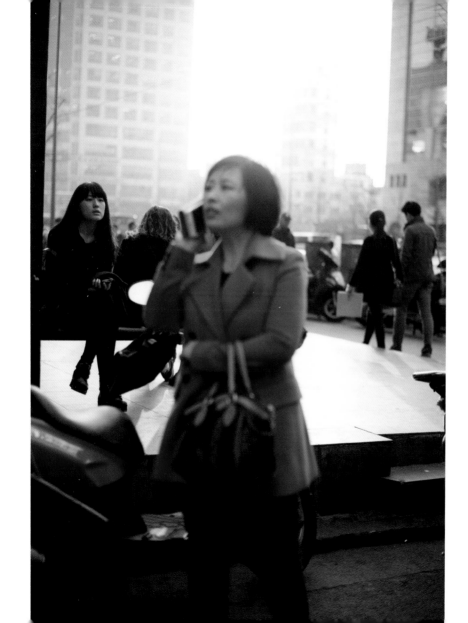

92

GO LONG

The longer your shutter speed, the harder it becomes to keep the camera still. A tripod will come in handy if you want to enhance the effect of movement in the picture. Put your camera on manual and use the self timer. That will ensure that the camera is perfectly still when the shutter opens.

It took me a few tries to figure out the best shutter speed for my shot outside the largest movie theater in Havana, Cuba. Once a few suitable cars lined up, I had to time the five-second exposure with the red light.

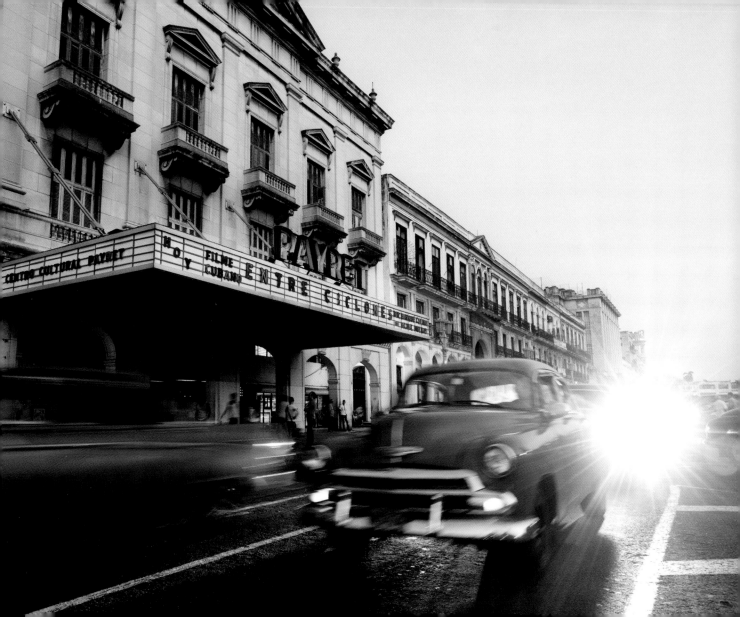

93

CONTRASTS

No, I'm not talking about the contrasts you are playing with in Photoshop. This is about the contrast between the objects within the frame. If you want to show something large, juxtapose it with something small. Young with old. Hot with cold.

In a baking-hot, no-suspension bus from Somewhere to Nowhere in India, I was crammed together with way too many people, according to standard safety regulations. The old lady and the infant girl were sharing a seat, surrounded by three generations of other passengers chatting amongst themselves. All the people around us made it easy for me to just sit and wait for the right moment, with the camera at my eye.

94

DANCING LIGHT

Another one of my favorite ways to create "punch" in a picture taken in the shade is to let the sunlight gleam through the leaves of the tree you're standing under. Let it play on your model's skin or use it to create an interesting texture on the wall behind her. Don't be afraid to let this kind of light hit your model's face as well.

We parked our bikes outside the winery after cycling around Italy's Apuglia region for hours. I was starving. The kind of starving that affects your vision and starts to make everything blurry. I noticed the owner's beautiful features when she served our food and wine, but my blood sugar was just too low to do anything about it. A while later, after finishing most of what was put on the table, I asked her if I could take her picture. Against the sand-colored wall, the sun shone through the olive leaves above.

95

THE IMPERSONATOR

In the first years of my career, I stole a lot. Not physical things, but the style and language of other photographers. There were a few photographers that I really loved and I analyzed every picture of theirs I could find, trying to figure out why they spoke to me. I then tried to mimic that style in my own pictures. At first, they were almost carbon copies. But over time I incorporated new inspirations into my work and after a while all the various influences blended into something that I can now call my own.

Located north of the Han River in Seoul, Gangbuk hosts a wide variety of hip and weird cafés. The name literally means "north of the river" as opposed to Gangnam, which is "south of the river". This young couple was heading home from a cat petting café (really!) and I just loved the glow of the neon lights. If you look closely, you might be able to find similarities with another well-known Swedish photographer's work. I won't tell you which one...

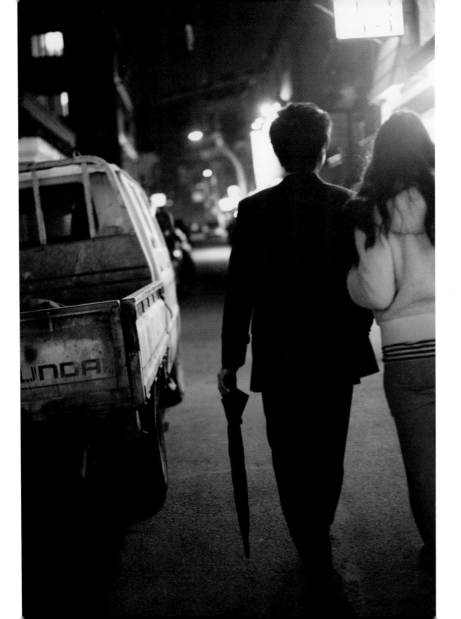

INTO THE SHADOWS

On a cloudless afternoon the sunlight is often
too harsh, making it pretty tough to photograph
faces. A quick fix (and a very good one) is to keep
your model in the shade. But while shooting
in sunlight will give you too much contrast, the
shade could leave you with too little. Even if
your model is in the shade, there'll always be
more light flowing in from another direction.
If you're standing in a tunnel or archway, the
entrance will be your source of light. If there's a
bright wall hit by sunlight close to where you're
standing, it will reflect brightness your way.
Look around, where is the light coming from?

In a rum bar somewhere in southern Barbados,
the owner was mixing drinks for us to try. He was
standing behind the bar under the shade of the
roof, but a large opening in front of him softly lit
one side of his face with daylight.

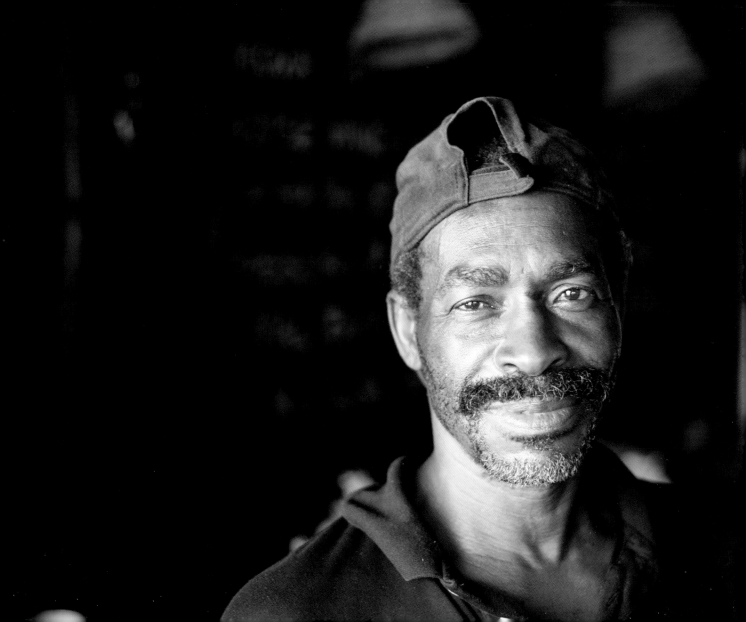

97

TELL A STORY

Professional travel photographers need to collect enough images to fill several spreads in a magazine. The challenge with travel articles is that the pictures have to be diverse, yet still have a common denominator so that they feel like they were all taken in the same place. A good way to practice this is to put five or six photos side by side, to create a short story. This will help you see what kind of images you are missing.

I went to the island of Capri just past Italy's Amalfi coast right before the full force of summer struck. The island was still pretty calm, at least when you got out of the center of Capri Town. My job was to capture all the elements of the island, but still make it feel like ONE island.

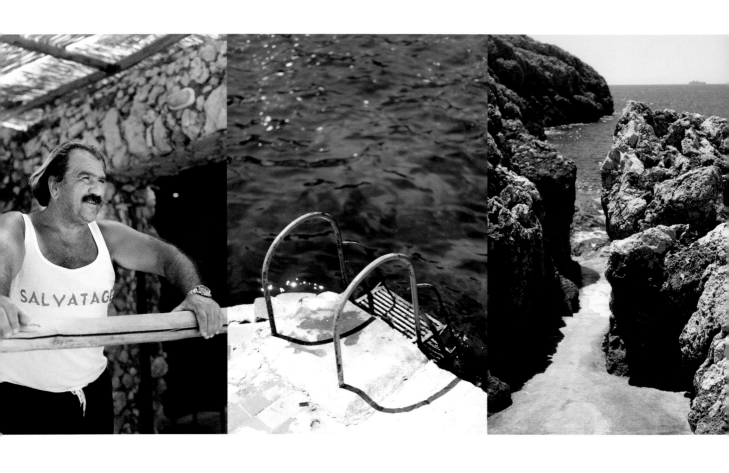

98

WORK WITH WHAT YOU'VE GOT

Many frustrated photographers have gone on shopping sprees when they can't get the pictures they want. Believing that a couple of new lenses or a new camera body will magically enhance their skills, they are just ignoring the facts – it's not the gear. Don't tell yourself that you need a new piece of equipment to be able to take "that" photo. Solve whatever problem you run into with the tools you already have.

Even though the light was very low, I managed to capture two security guards keeping the English teenagers that invaded the city under control. By keeping my elbows tight to my body and leaning against a lamp post, I was able to keep the camera still long enough to freeze the moment. A flash would have ruined the mood; a tripod would have made me too visible.

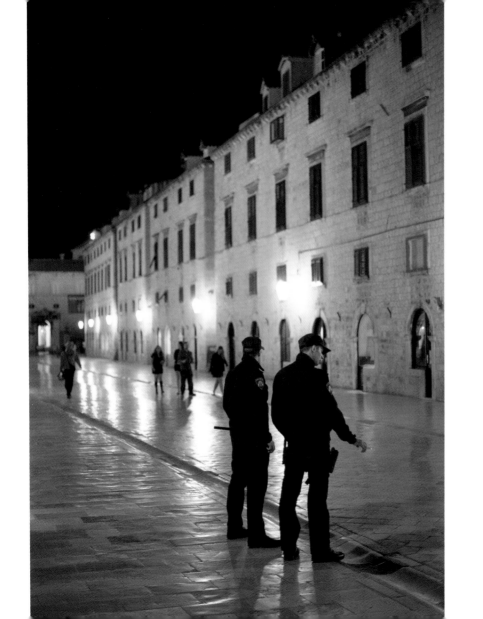

EMBRACE WHAT YOU HATE

I have a phobia. I'm not sure what it is called, but I just can't stand other tourists! Whenever the percentage of bad-fitting shorts and white tube socks gets too high, I feel like the walls are closing in. I guess too many tourists make it feel less genuine to me. But honestly, it's really more of a love/hate relationship. Most of them are very photogenic and sometimes I can spend hours trying to capture them.

Dubrovnik. Whew! I arrived with the ferry early in the morning. It was just after 7 am when I passed through the city walls and sat down with an espresso to get a feeling for the place. The cobblestoned main street was almost empty. Just a few locals who were on their way to work. A few hours later, after I finished unpacking at my guesthouse, my heart almost stopped. The streets were filled with groups of tourists, each following a tour guide waving a flag on a stick.

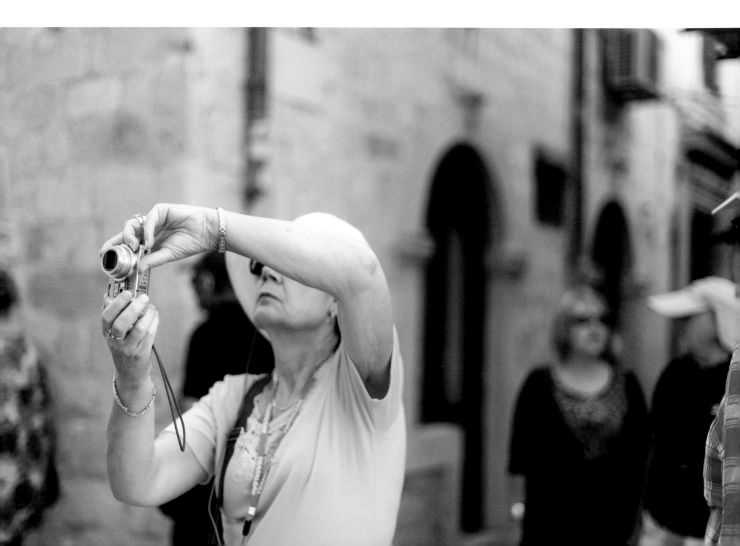

100

JUST SHOOT

There's no shortcut to becoming a good photographer. There's nothing I can teach you that will make you start producing award-winning pictures tomorrow. The only way to learn photography is to take pictures. Shoot every day. Travel and meet people. Spend less time behind your computer and get out and talk to other photographers.

You don't have to travel far to practice your travel photography skills. On a late summer night, not too far out of my hometown, I drove with a couple of friends to a jazz festival in the middle of nowhere. Standing in a circus tent together with hundreds of zoot suits, the only light sources were a few light bulbs and the stage spots. The energy on the dance floor was amazing.

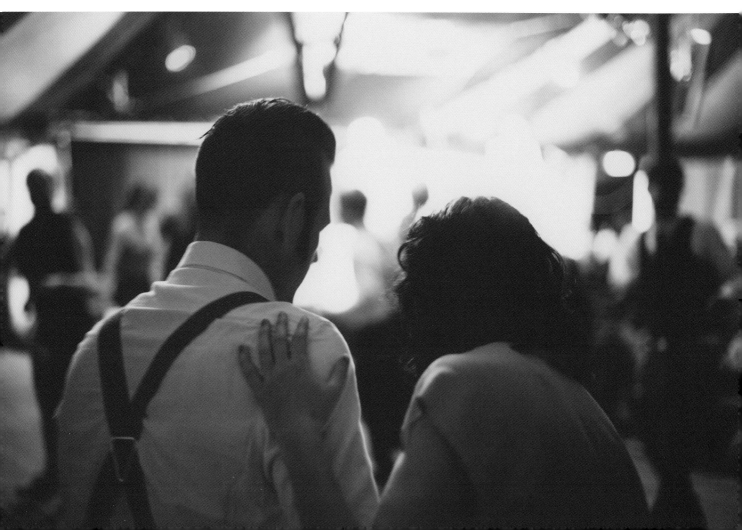

EXERCISE 5: TELL A SHORT STORY

When shooting for a longer travel article, you have two main challenges that almost contradict each other. When arranging the images in the actual layout, the art director needs them to be diverse enough so that they don't feel too identical, but similar enough to unite the article and provide consistency. If you're on a major assignment, you'll have to summarize the pictures taken every day to make sure you capture everything you need.

This exercise will take you a few steps closer to publishing your first article in a travel magazine. You'll learn to:
• Capture all the building blocks of a travel article
• Choose which images go well with others
• Keep a common thread running throughout the article

STEP 1

Choose a specific destination that you think could work well as a travel article. Pick a spot that covers a small, well-defined area, like a restaurant, market or café. The larger the area, the harder it will be to keep the story united. Make sure there are some people on the scene.

STEP 2

Spend as long as you like capturing all the elements you need to create a reportage that shows how the location both looks and feels. Make sure you get a variety of wide shots and close-ups, pictures with and without people, and images with people looking into and away from the camera. The goal is to capture as many different pictures as possible, and each should add something to the full story.

STEP 3

Transfer all the images to your computer and start selecting the images you like. Whatever application you are using, find a way to view the pictures side by side. Now, work towards finding the 10 photographs you want to include in your reportage. When placed side by side, it's easier to see which photographs work well together. It's also easy to see what you're missing, like perhaps pictures of people or a general environment shot. An outspoken friend could be a great help in finding the missing pieces in your article. Tell him or her not to hold back on the feedback! You are doing this to improve.

Before I got my first gig for a travel magazine, I spent hours looking through old articles, making notes beside every picture. I tried to sort them into categories and learn which building blocks you need to create a successful reportage. Buy an issue of your favorite magazine and start analyzing. When you've finished this exercise, see if you have the same types of pictures that your favorite photographer included in his or her article.

COLOPHON

Published by *new Heroes & Pioneers*.

Beyond the Pictures Collection

Photography and text by **Jens Lennartsson**

Book design by **Joke Mestdagh**

Edited by **Liz Keel**

Printed and bound by **Kopa (Lithuania)**

FSC
www.fsc.org
FSC® C103625

The mark of
responsible forestry

Legal deposit December 2013

ISBN 978-91-981413-0-6